The Dance of Death Coloring Book

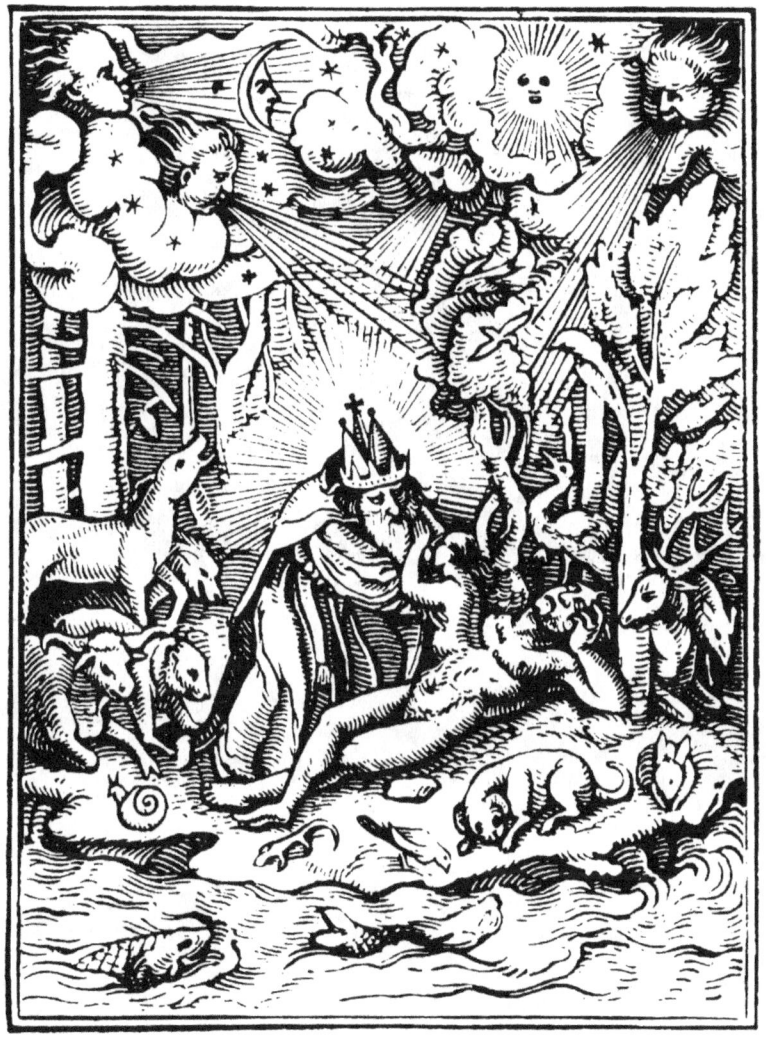

Being the Woodcut Designs of
Hans Holbein

Compiled & Edited by Jeff Bacon

© 2015 Jeff Bacon
ISBN: 978-1-329-68410-2
The images used in this book are in the public domain and may be copied and reused.

Les simulachres &

HISTORIEES FACES
DE LA MORT, AVTANT ELE
gammēt pourtraictes, que artifi-
ciellement imaginées.

Vsus me Genuit.

A LYON,
Soubz l'escu de COLOIGNE,
M. D. XXXVIII.

Table of Contents

The Dance of Death	i	The Knight	22
The Creation	1	The Advocate	23
The Temptation	2	The Magistrate	24
The Expulsion	3	The Physician	25
The Pope	4	The Astrologer	26
The Cardinal	5	The Gentleman	27
The Bishop	6	The Merchant	28
The Abbot	7	The Old Man	29
The Abbess	8	The Old Woman	30
The Canon	9	The Bride and Groom	31
The Preacher	10	The Child	32
The Priest	11	The Peddlar	33
The Monk	12	The Husbandman	34
The Nun	13	The Soldier	35
The Emperor	14	The Gamblers	36
The Empress	15	The Drunkards	37
The King	16	The Robber	38
The Queen	17	The Blind Man	39
The Duke	18	The Wagoner	40
The Duchess	19	The Cemetery	41
The Count	20	The Last Judgment	42
The Countess	21		

The Dance of Death

For most of human history, death has been our constant companion. Even today, in many countries, the idea of death as an integral part of life is prominent.

The Dance of Death, or Danse Macabre in French, is a late-medieval allegory on the universality of death: whether rich and powerful or poor and helpless, the dance we do with Death unites us all.

The earliest visual record is from the cemetery of the Church of the Holy Innocents in Paris (1424-25), although it no longer exists. Other artists, including Bernt Notke, Vincent of Kastav, John of Kastav, and Pieter Brueghel the Elder addressed the subject in their art.

My favorite treatment, reproduced here, is the wood cuts designed by Hans Holbein the Younger (1497-1543) in 1526 while he was in Basel and cut by the accomplished Formschneider (block cutter) Hans Lützelburger.

Each image has been carefully restored, to the best of my ability, and is suitable for framing either in the original black and white or with whatever fanciful colors you choose to include. I hope you enjoy the beauty of the work of Holbein and Lützelburger as reproduced here and that you enjoy many pleasant hours of coloring.

Jeff Bacon

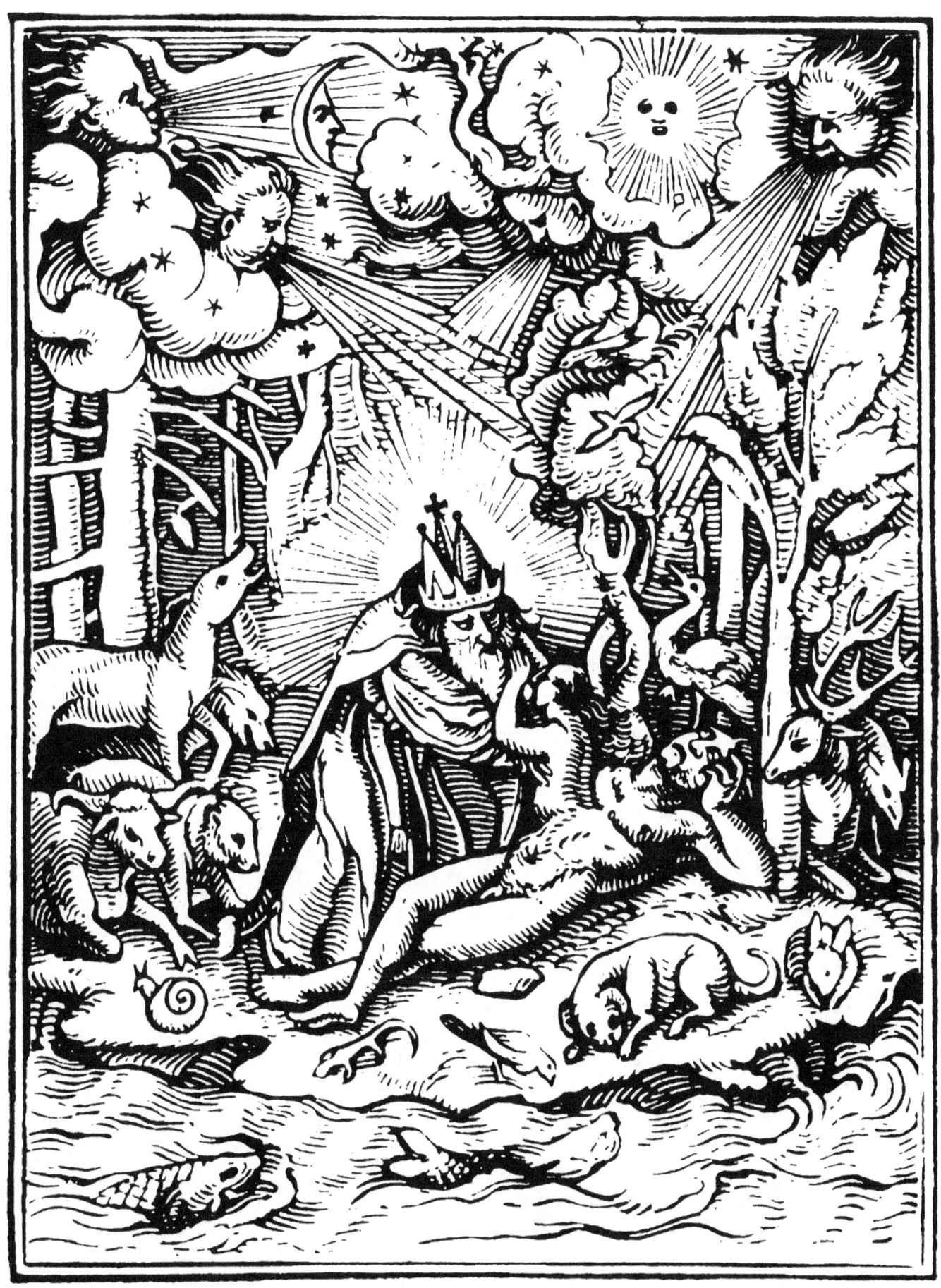

1 The Creation

1. The Creation.

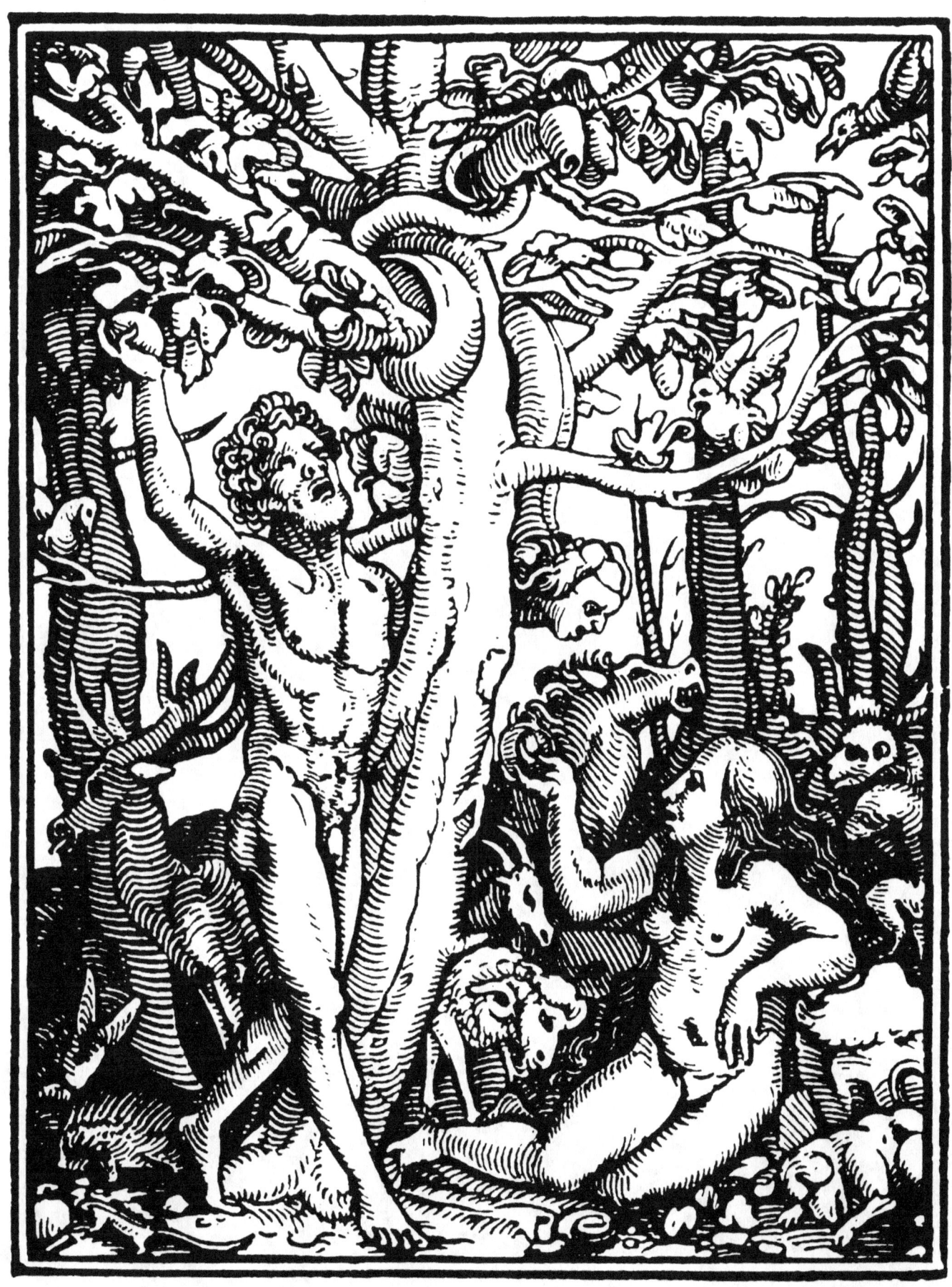

2 The Temptation

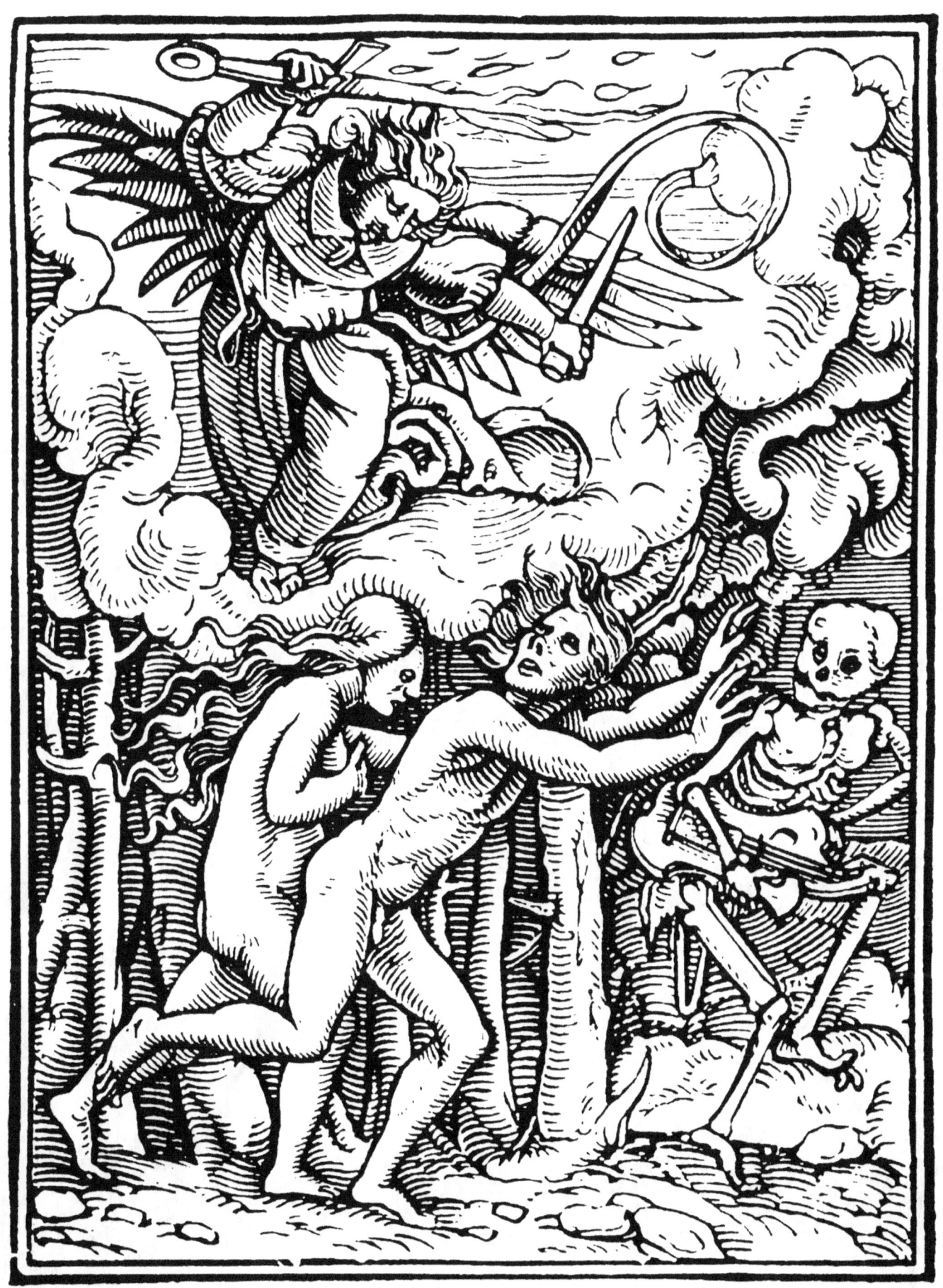

3 The Expulsion

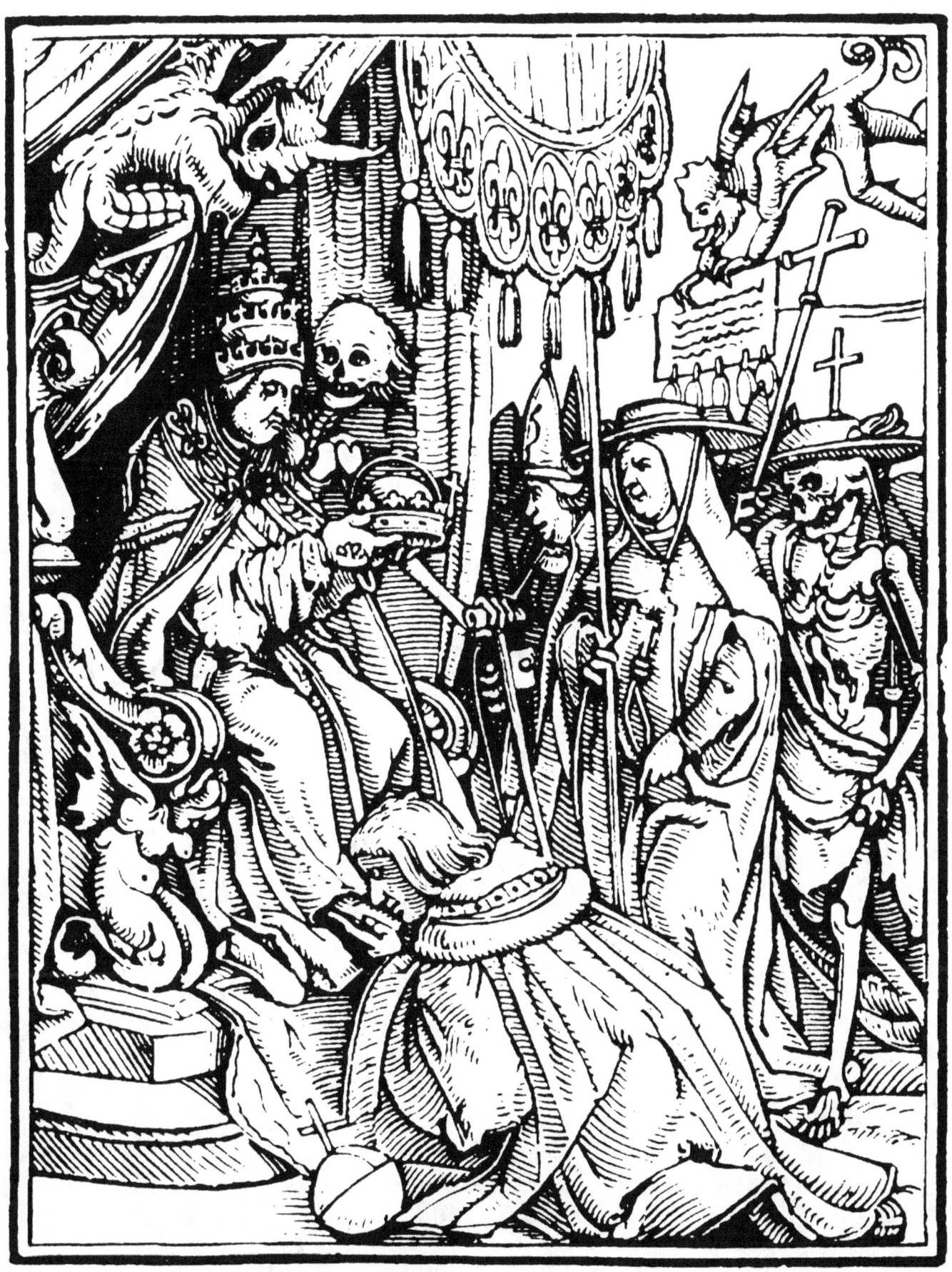

4　The Pope

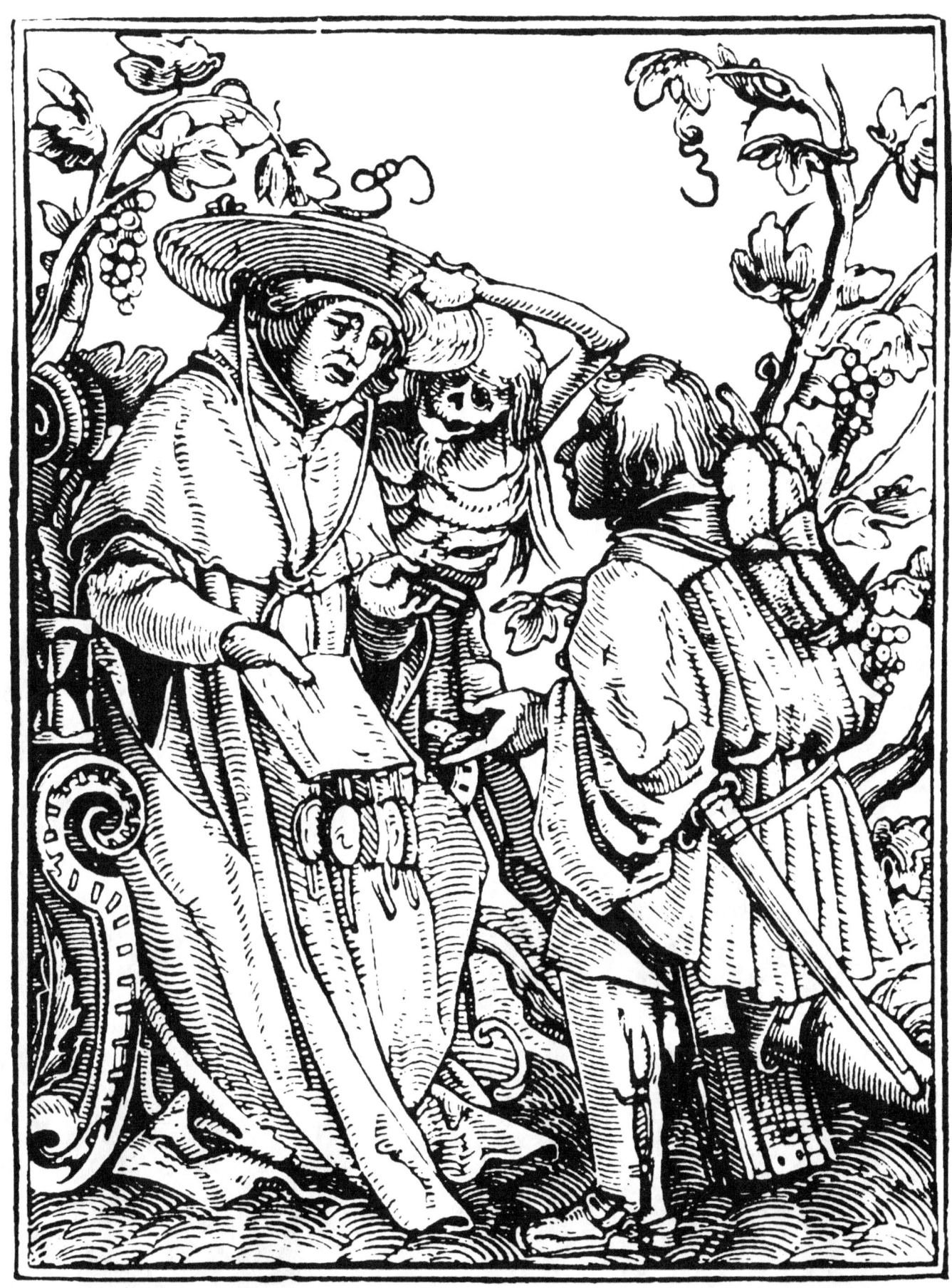

5 The Cardinal

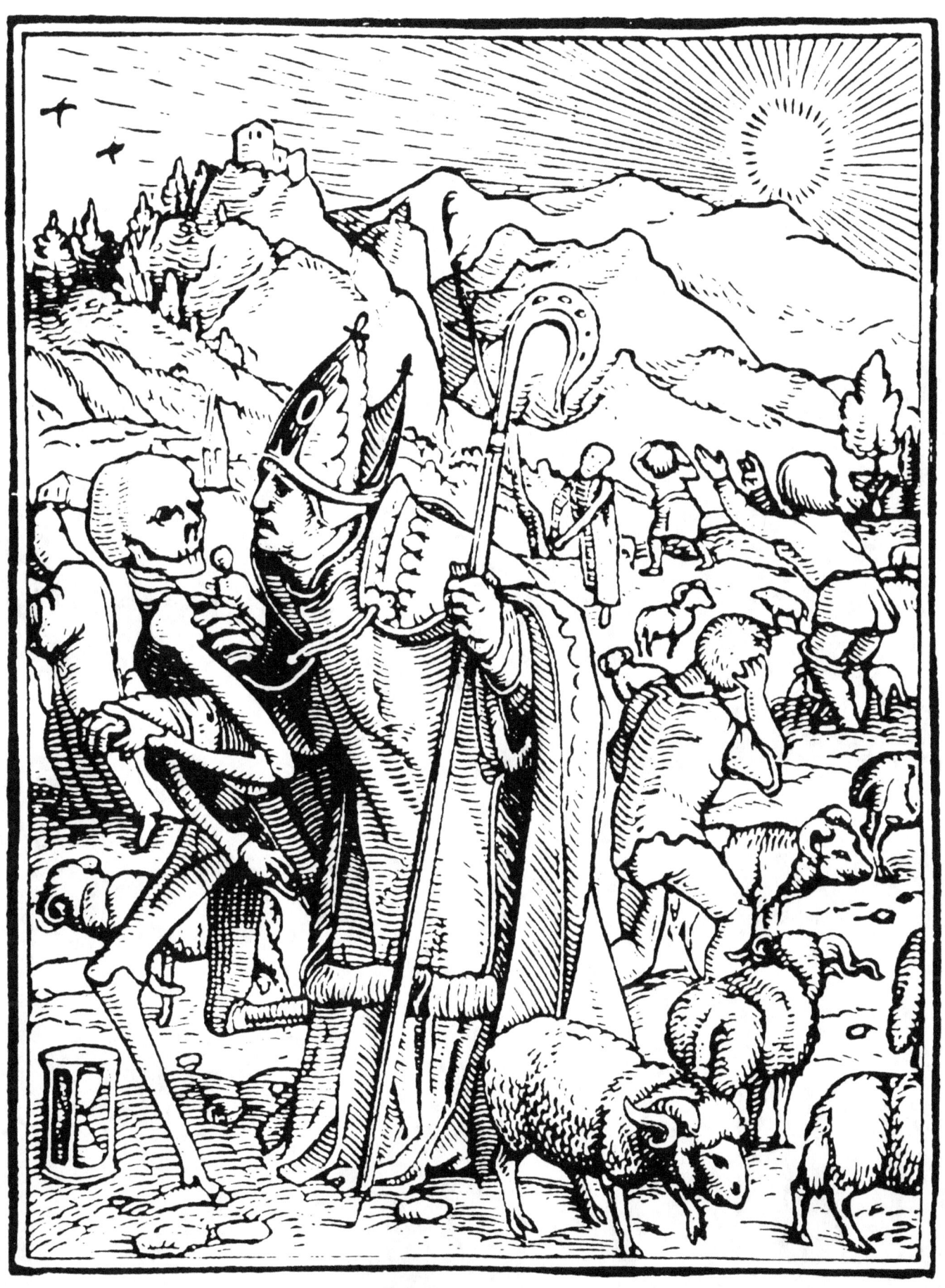
6 The Bishop

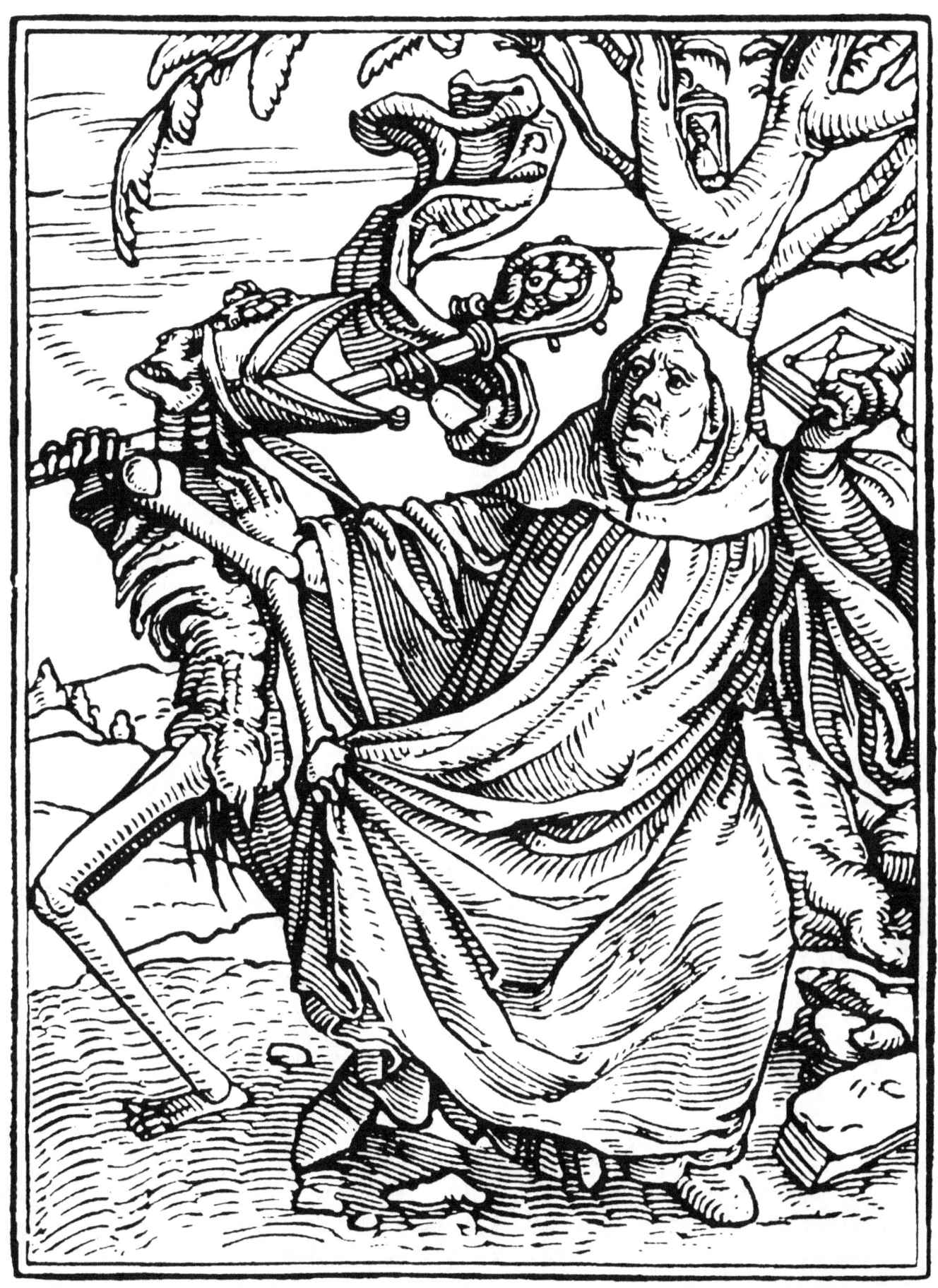

7 The Abbot

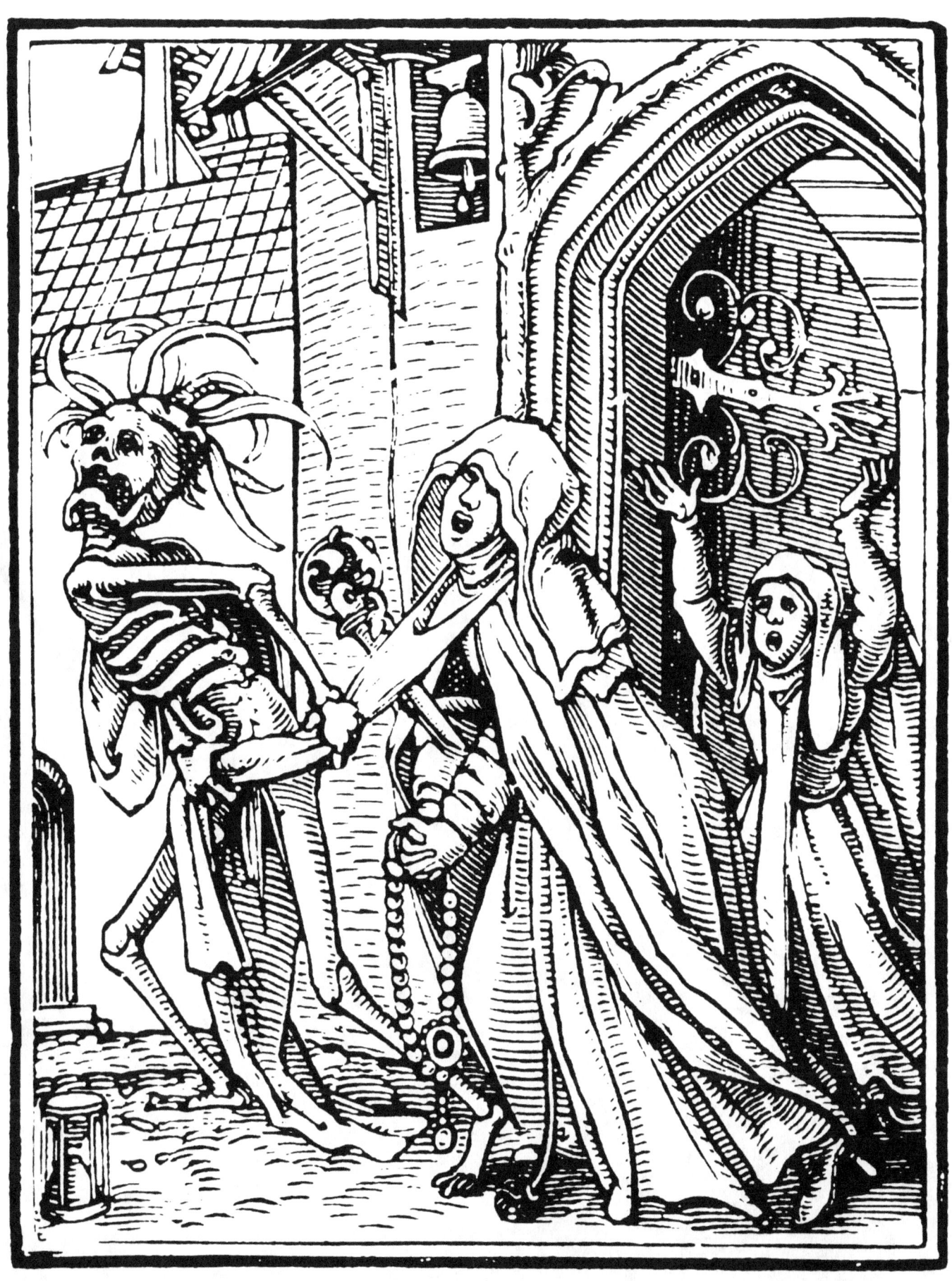

8 The Abbess

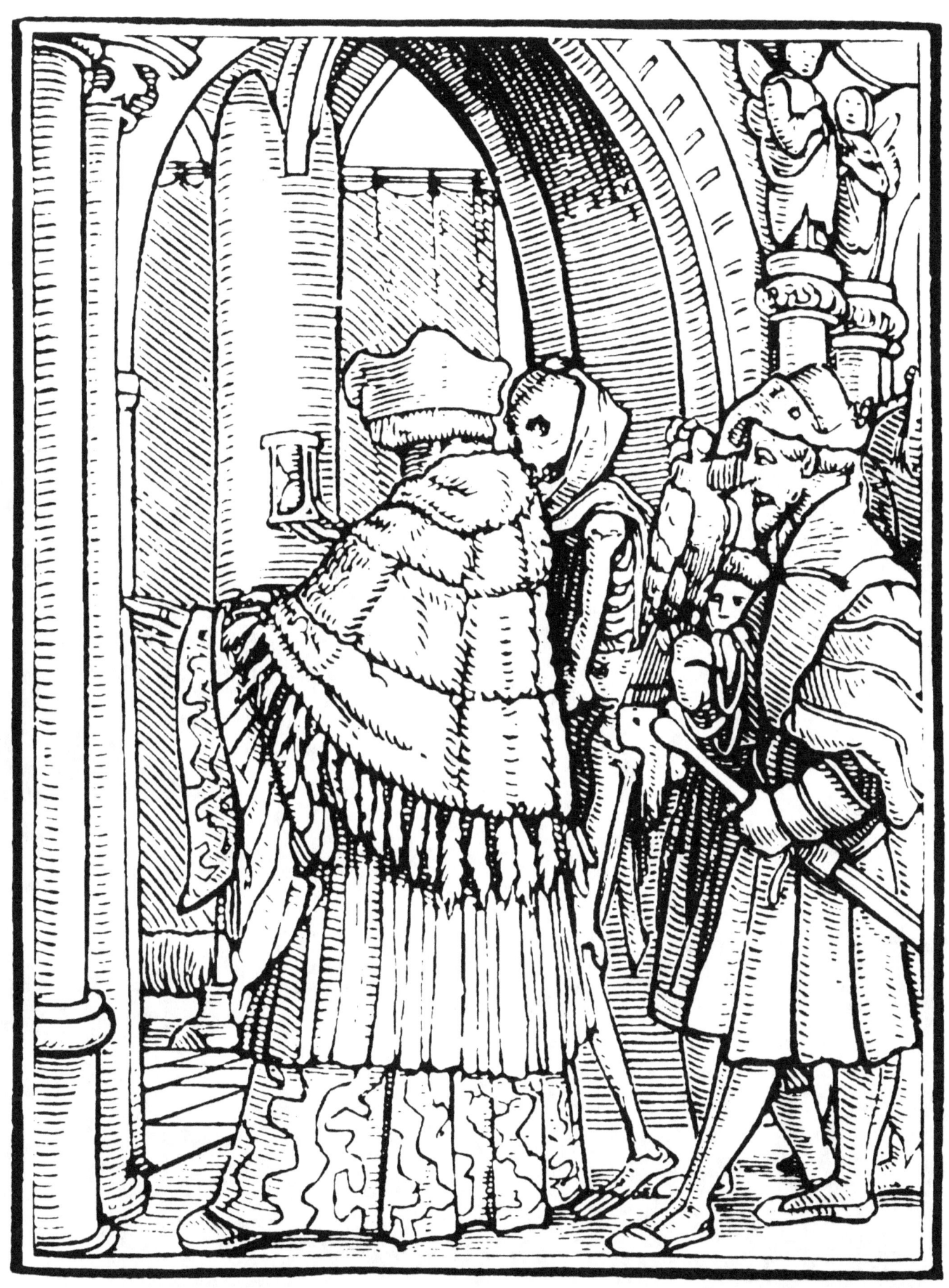

9 The Canon

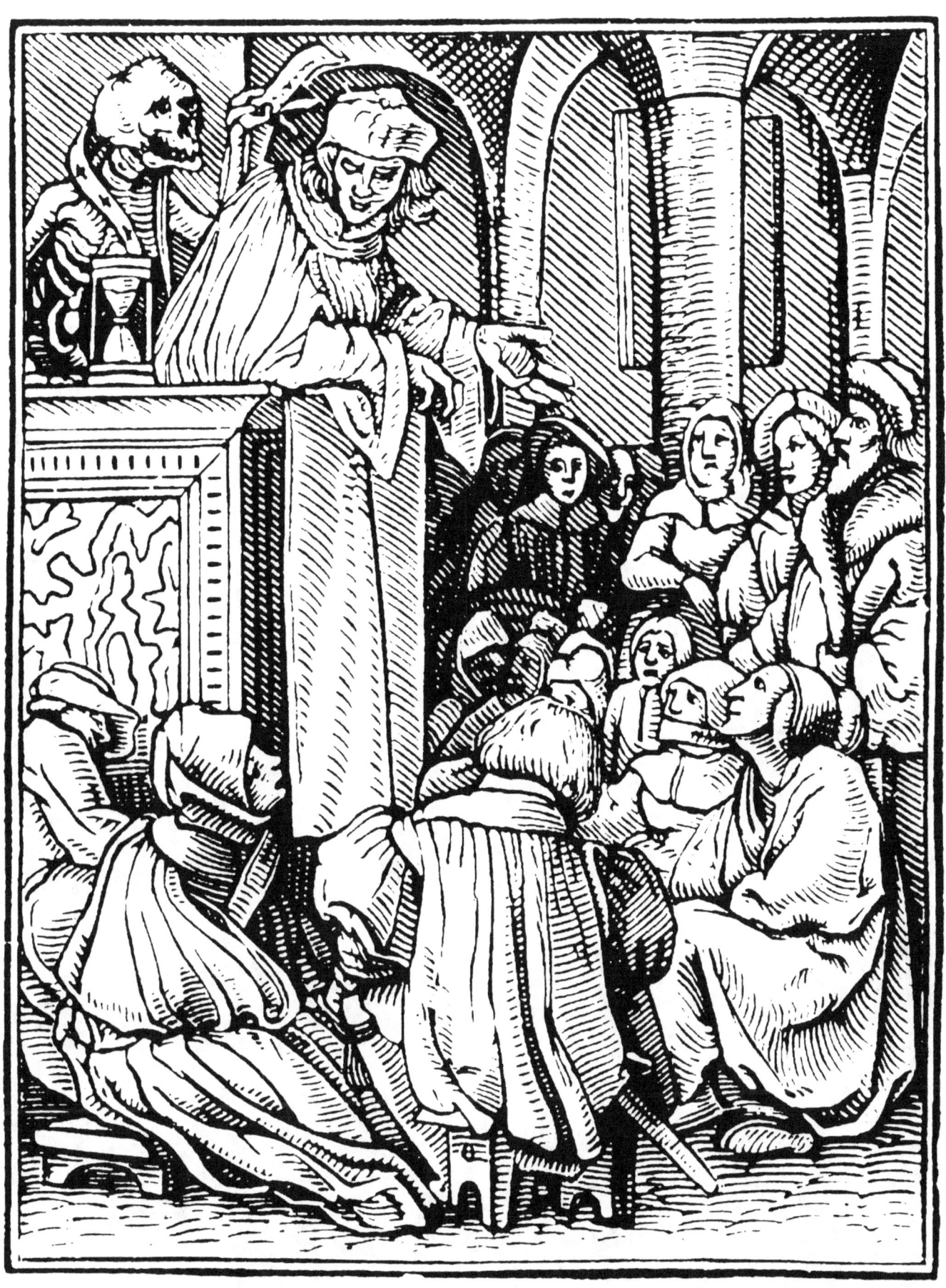

10 The Preacher

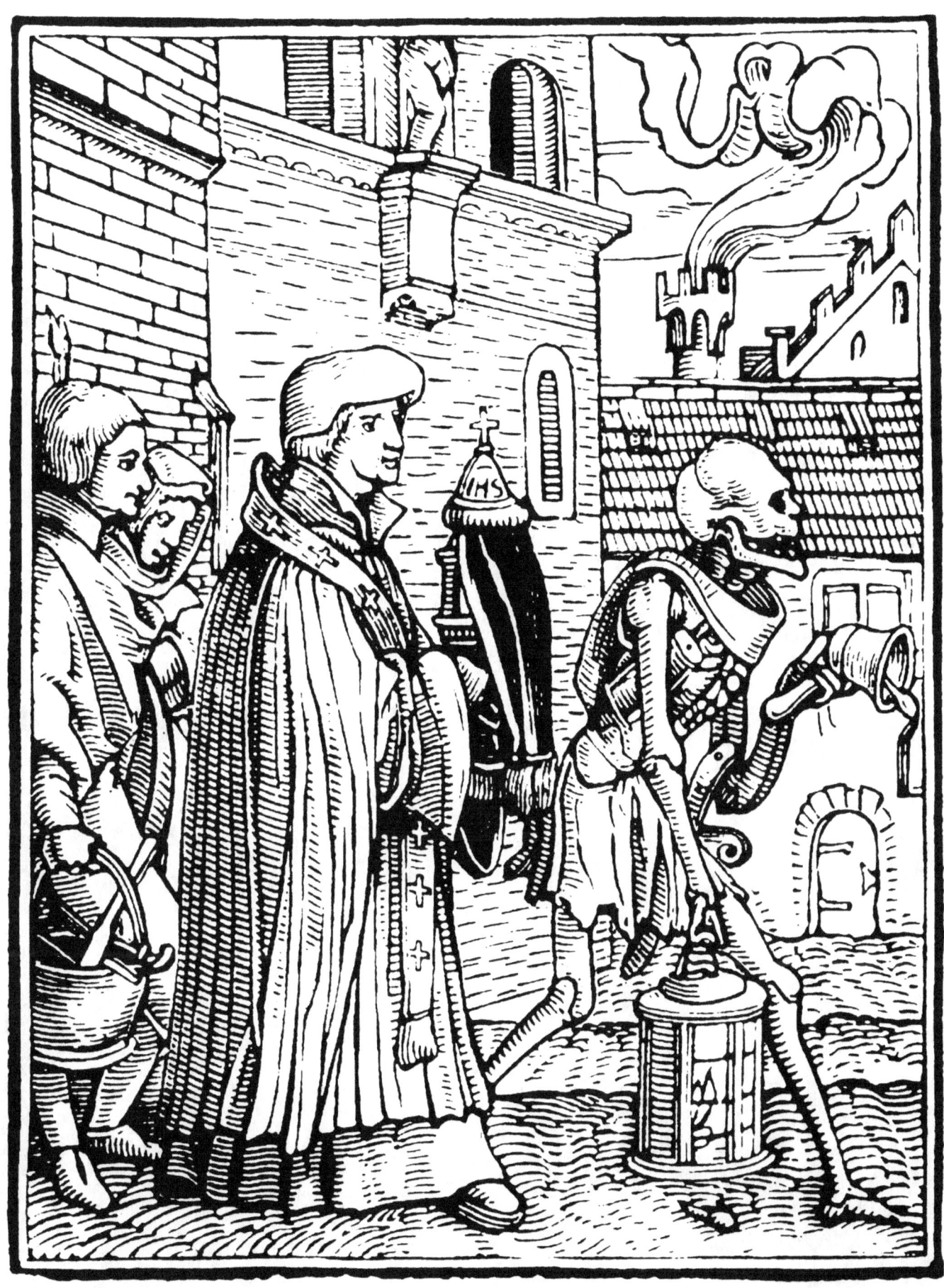

11 The Priest

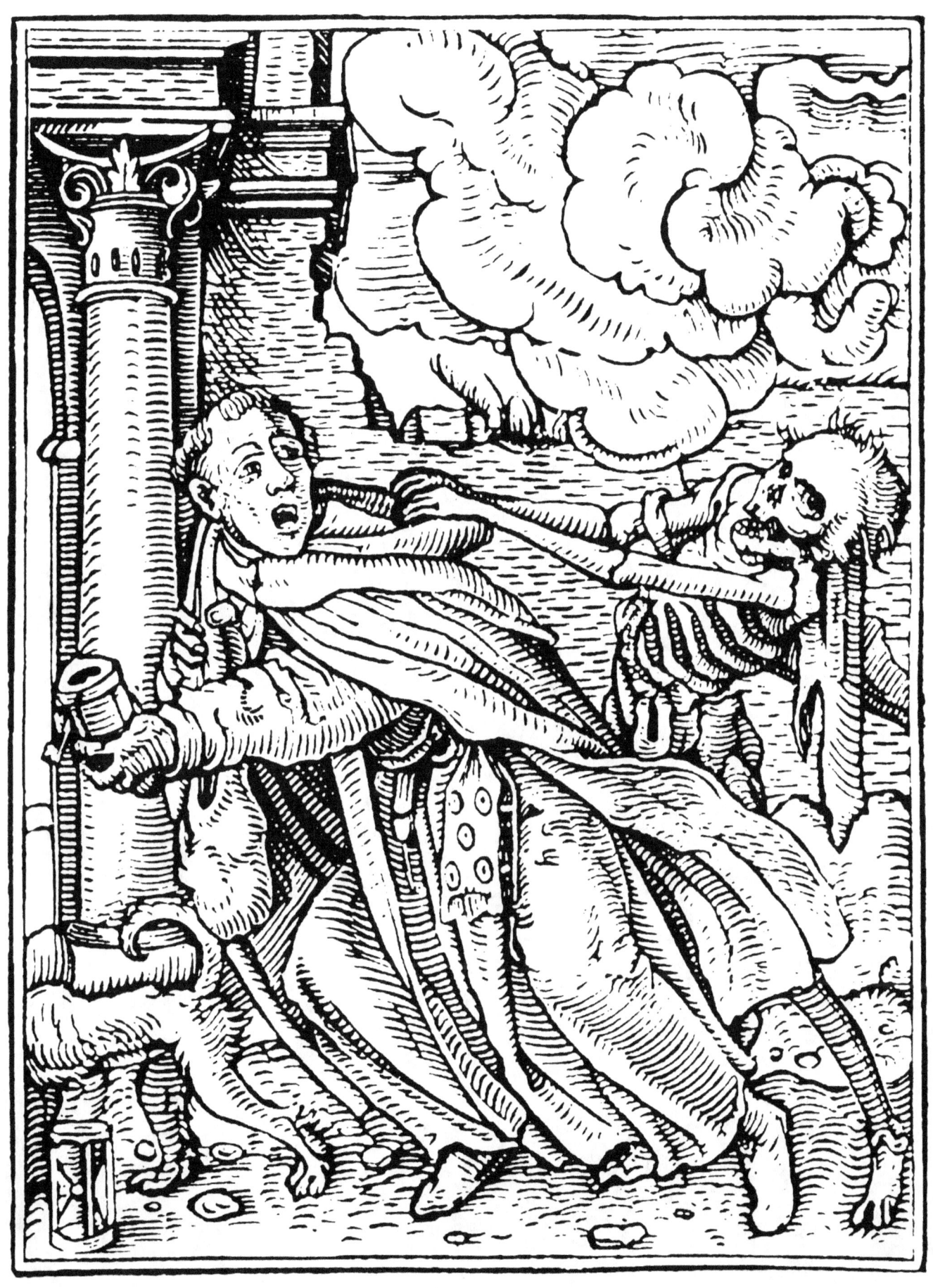

12　The Monk

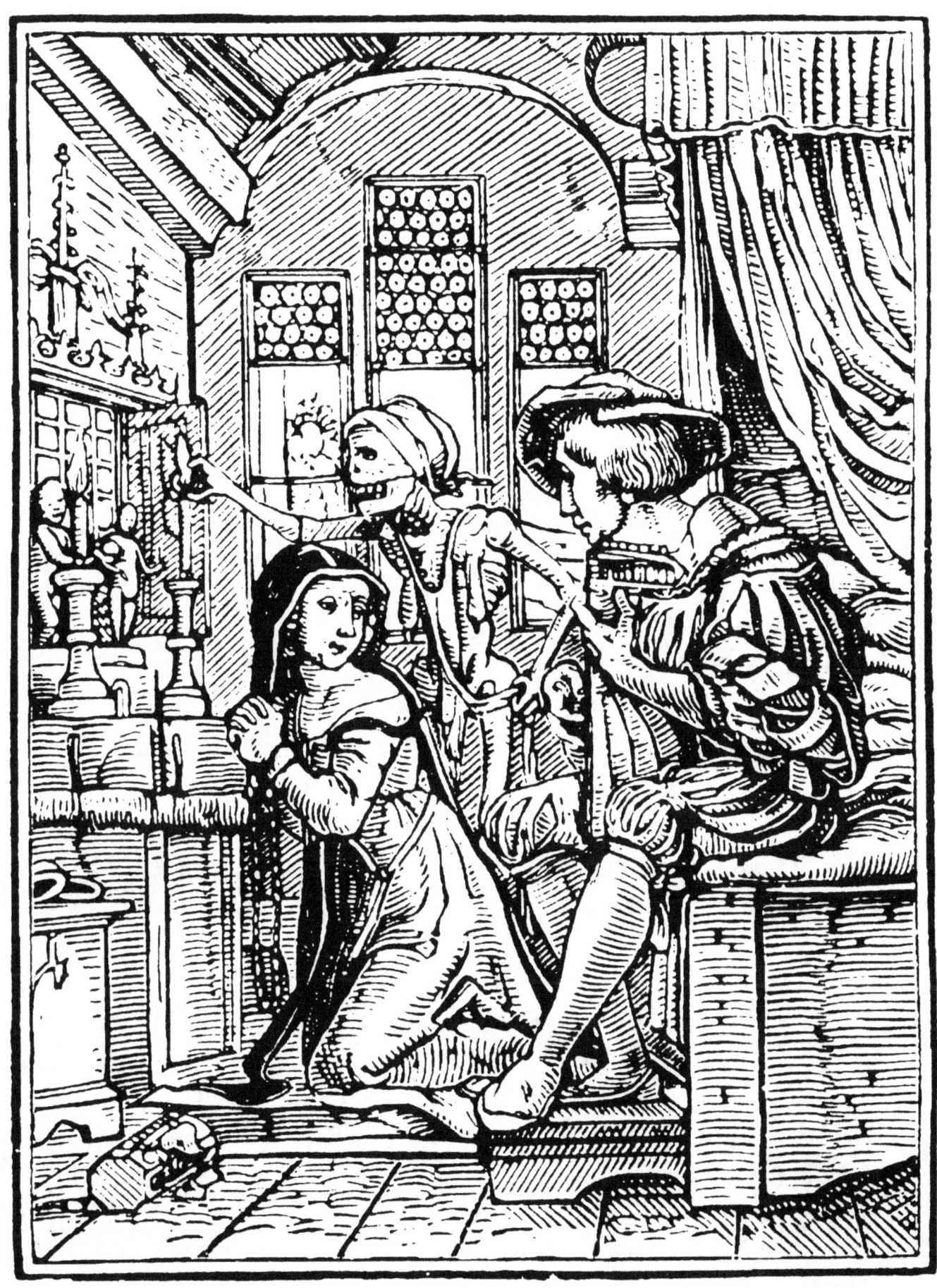

13 The Nun

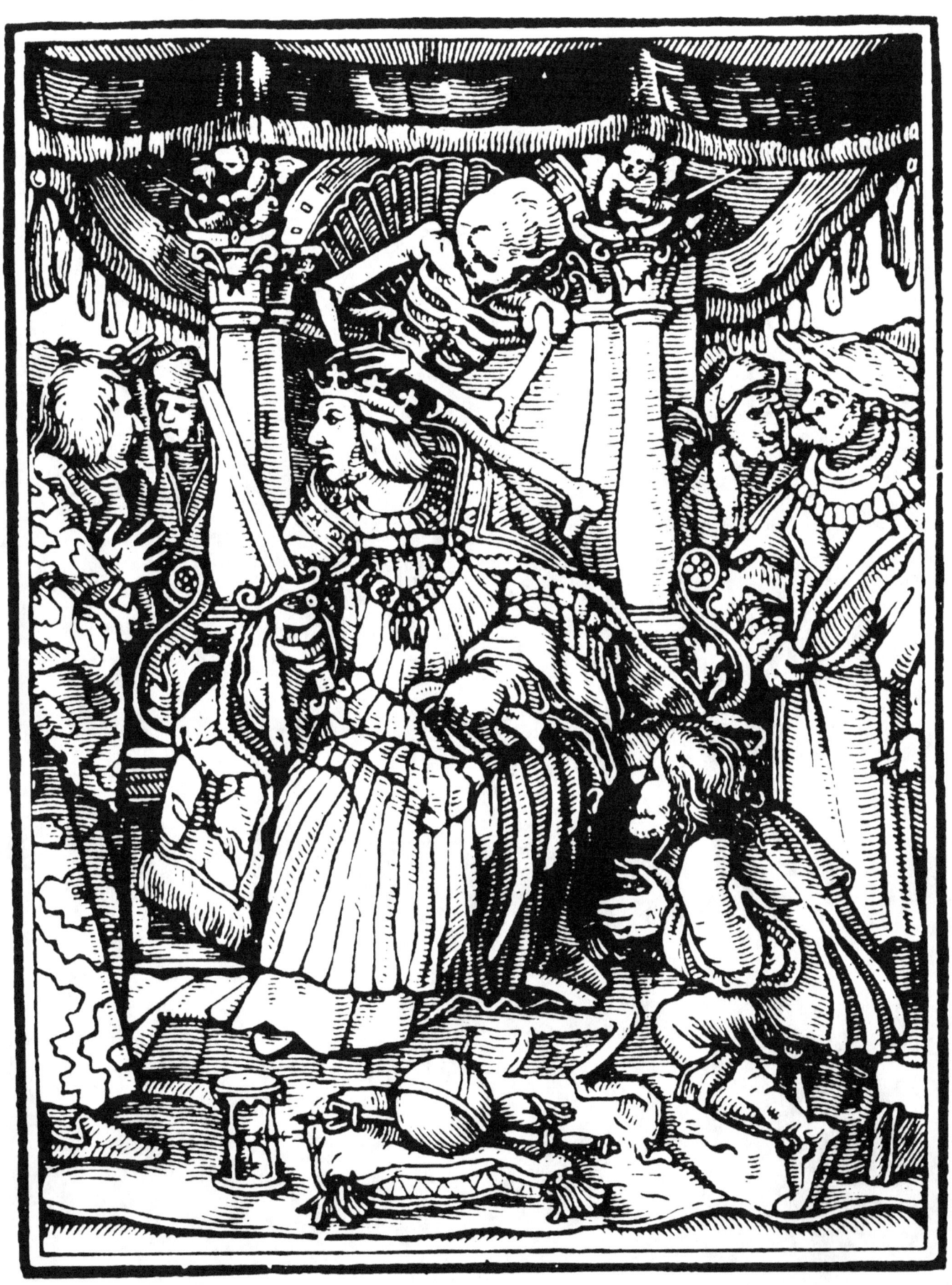
14 The Emperor

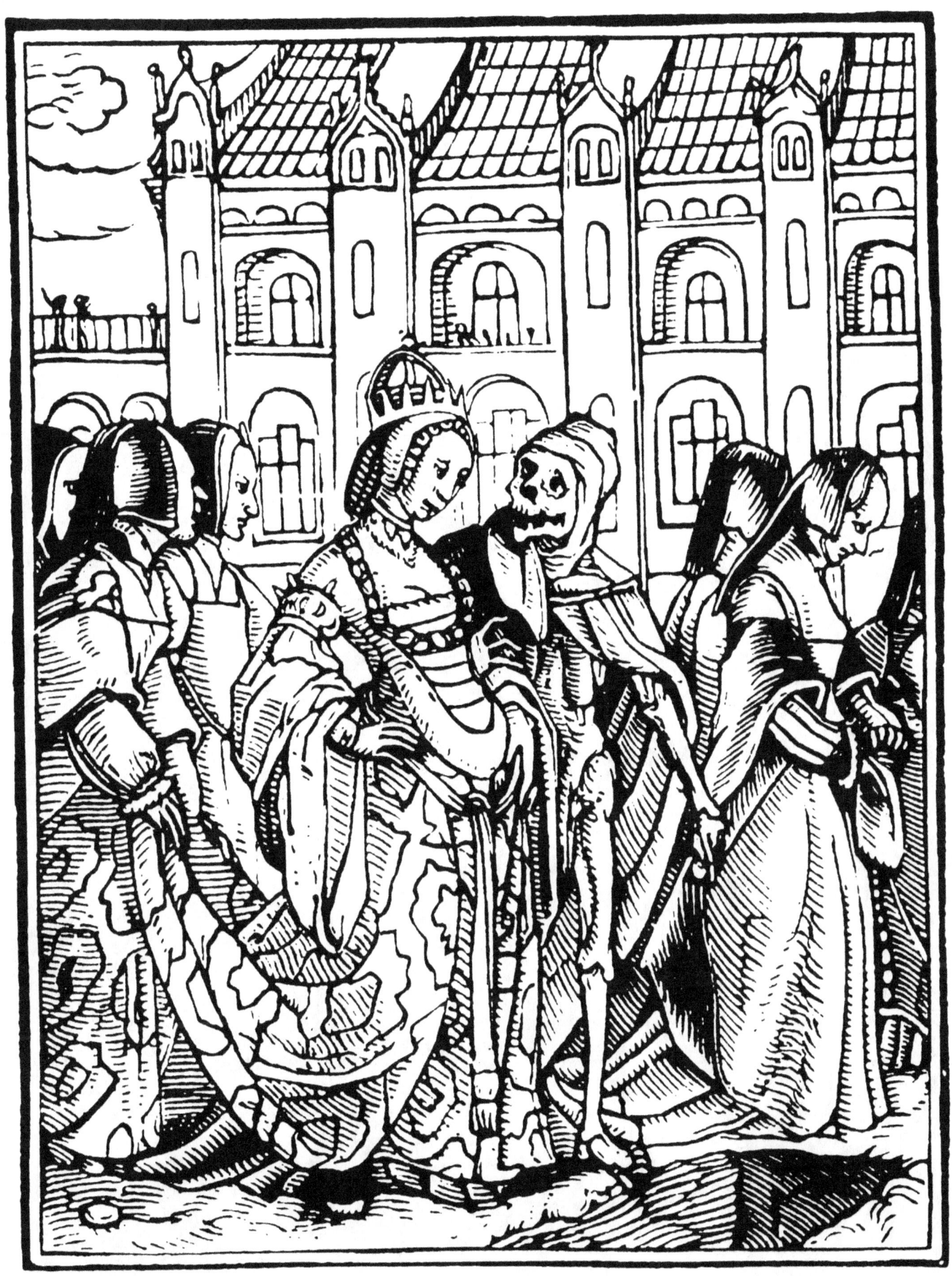

15 The Empress

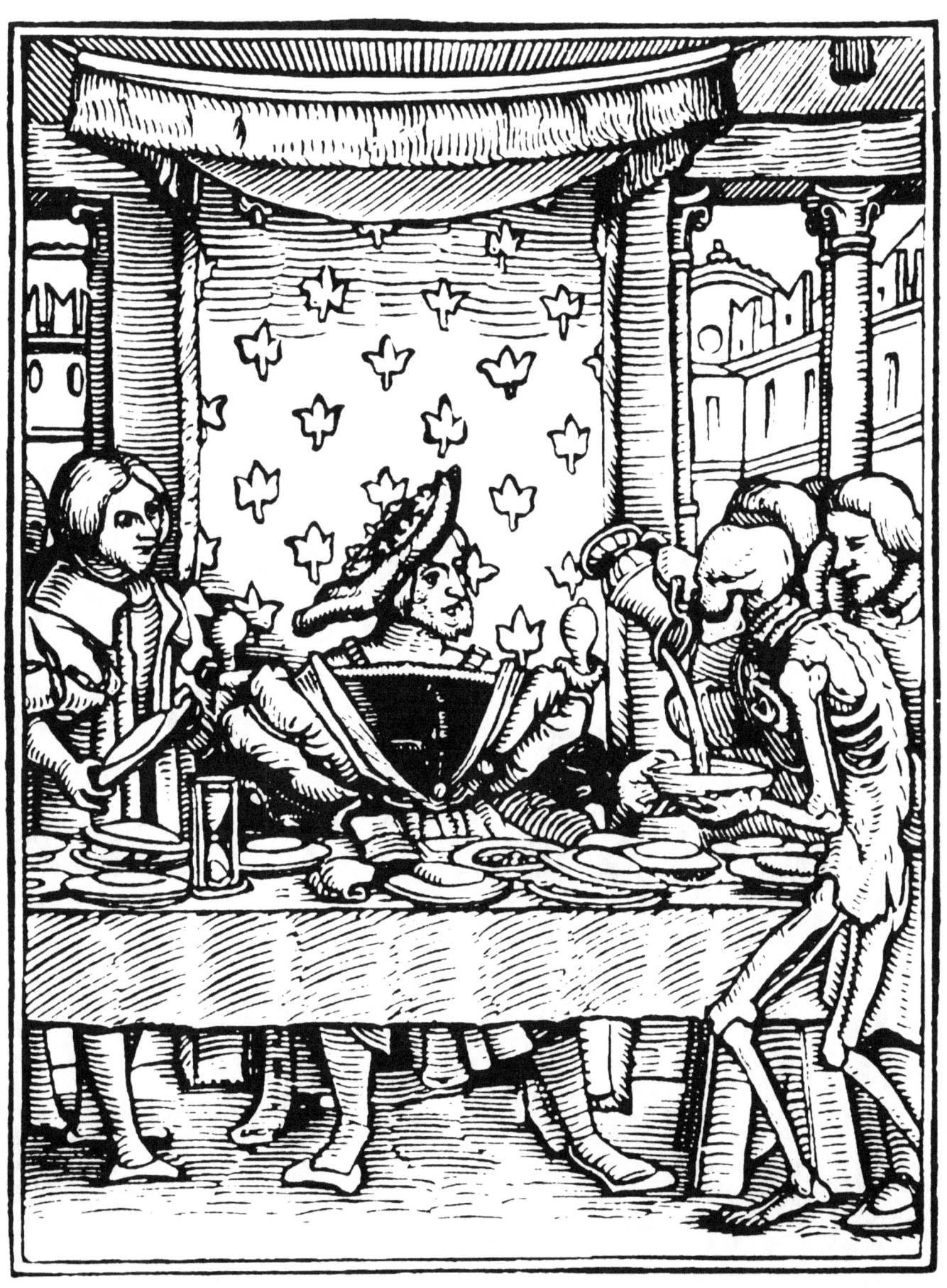

16 The King

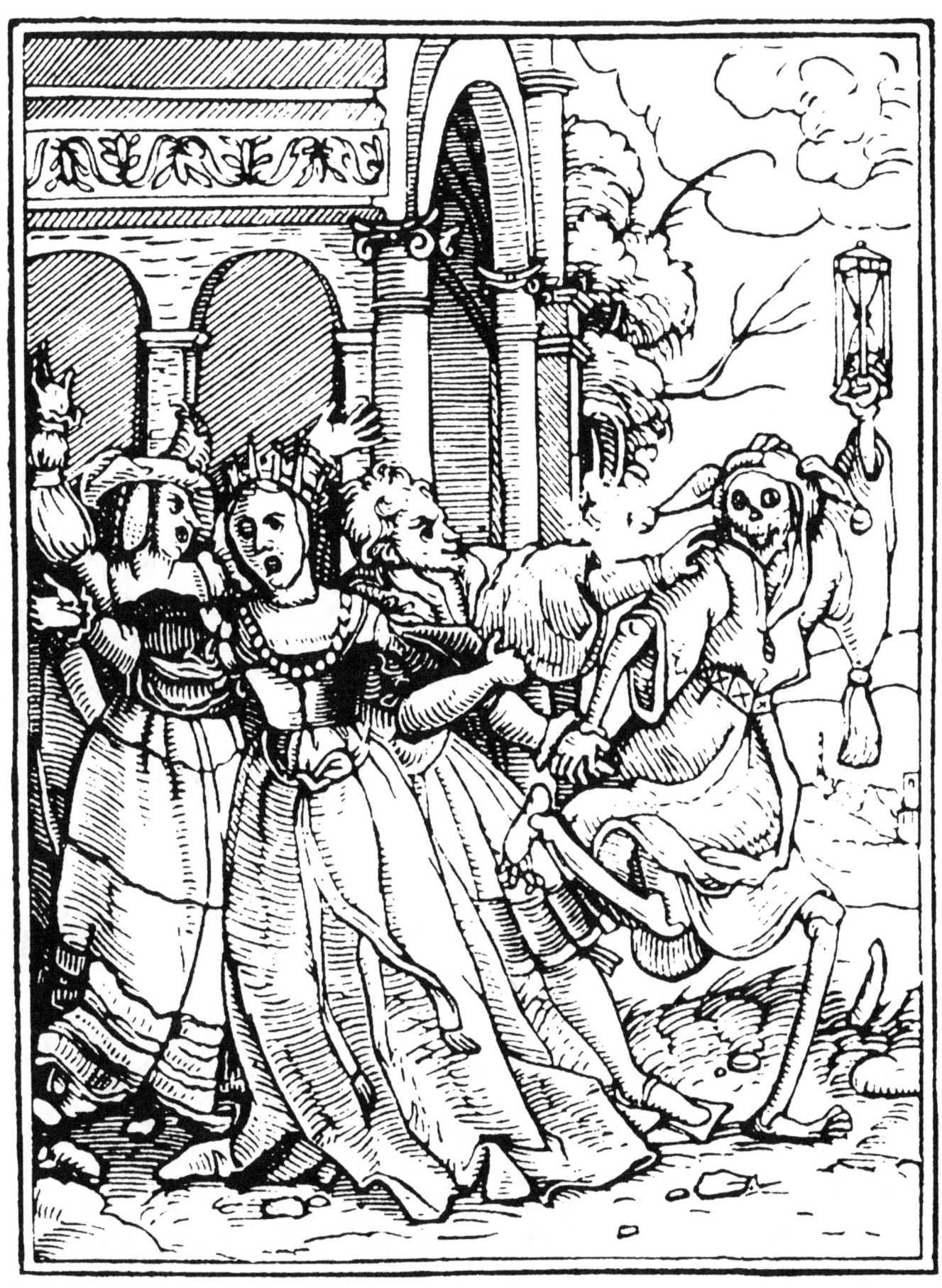

17 The Queen

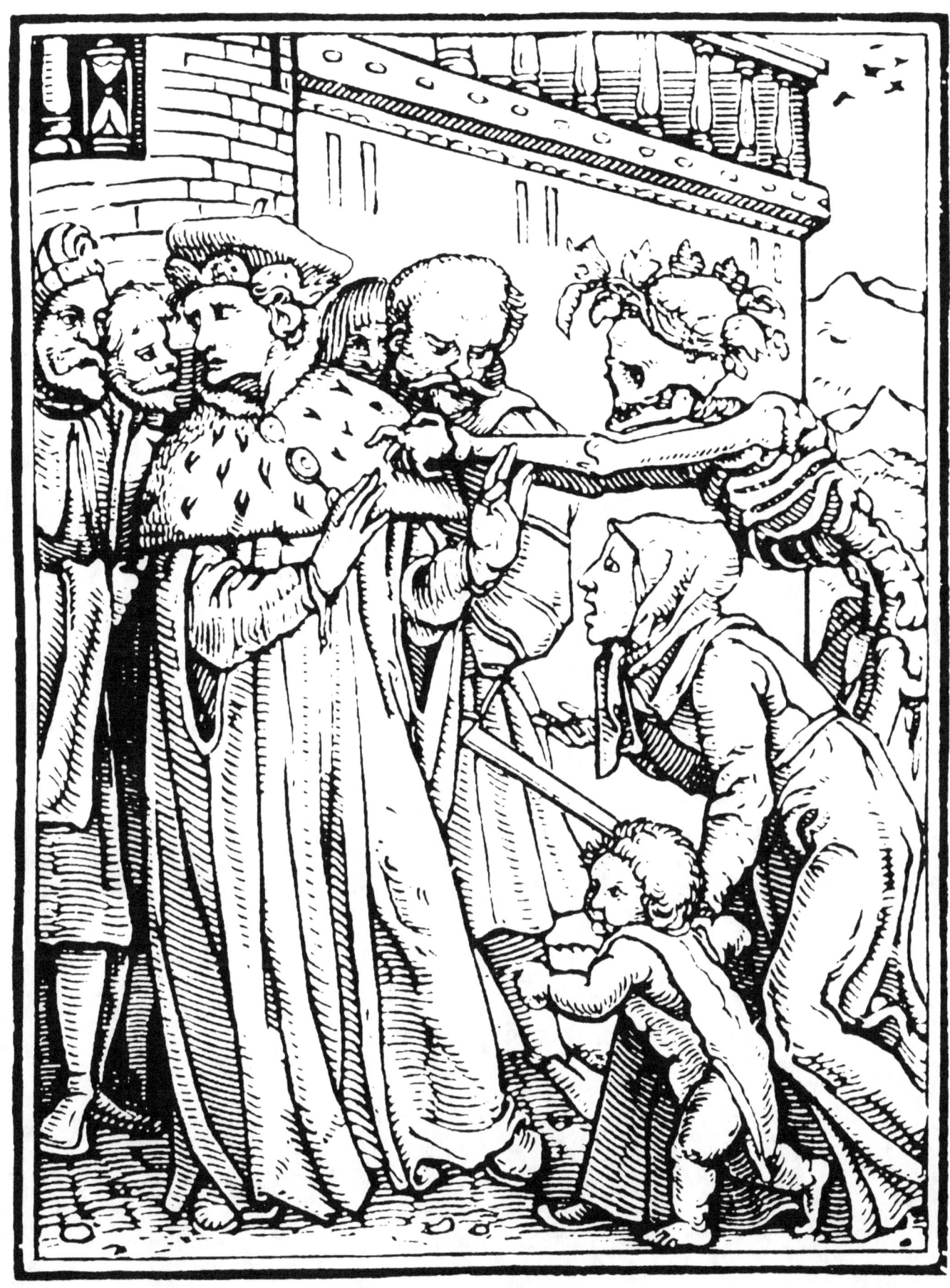

18 The Duke

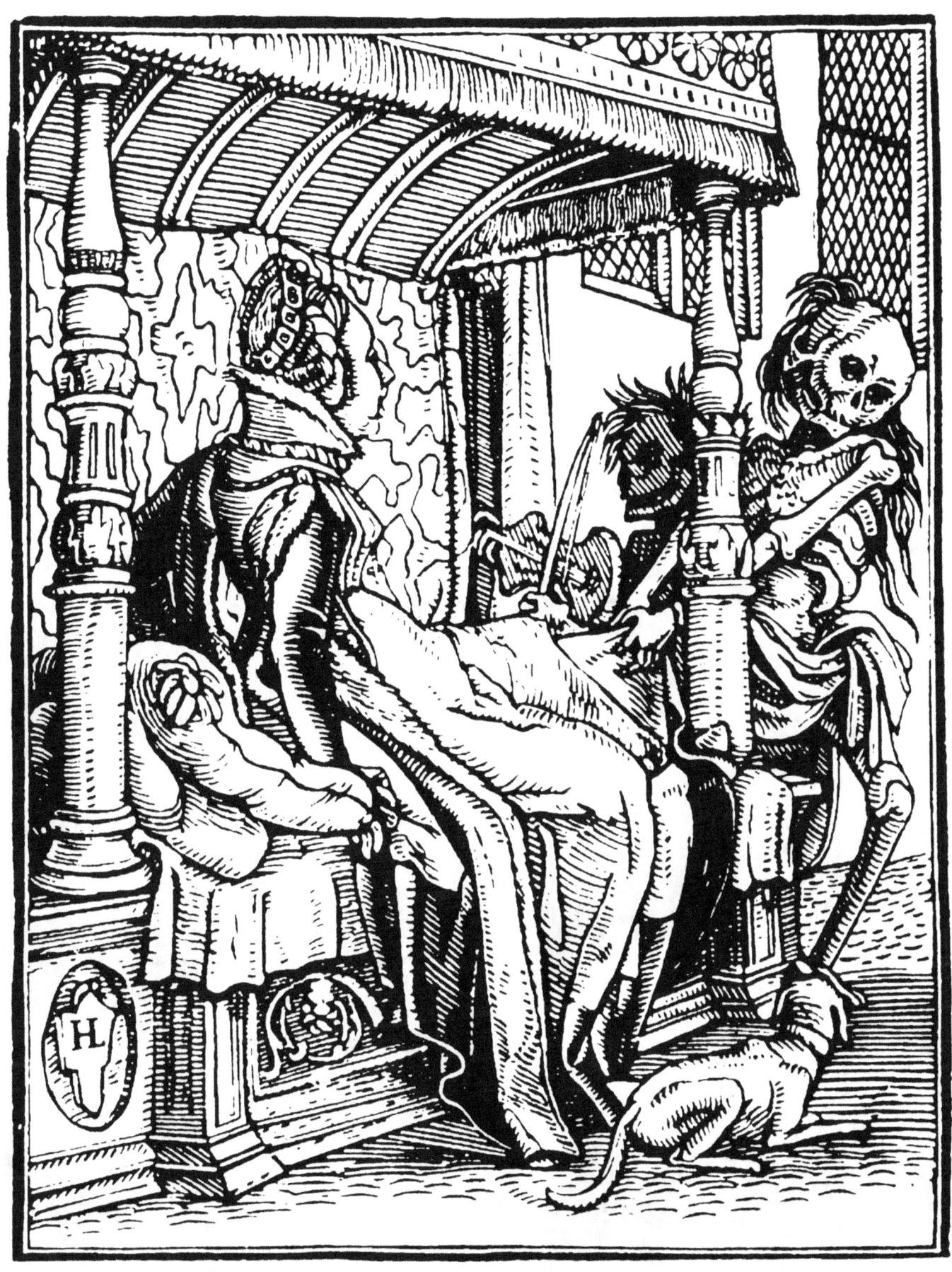

19 The Duchess

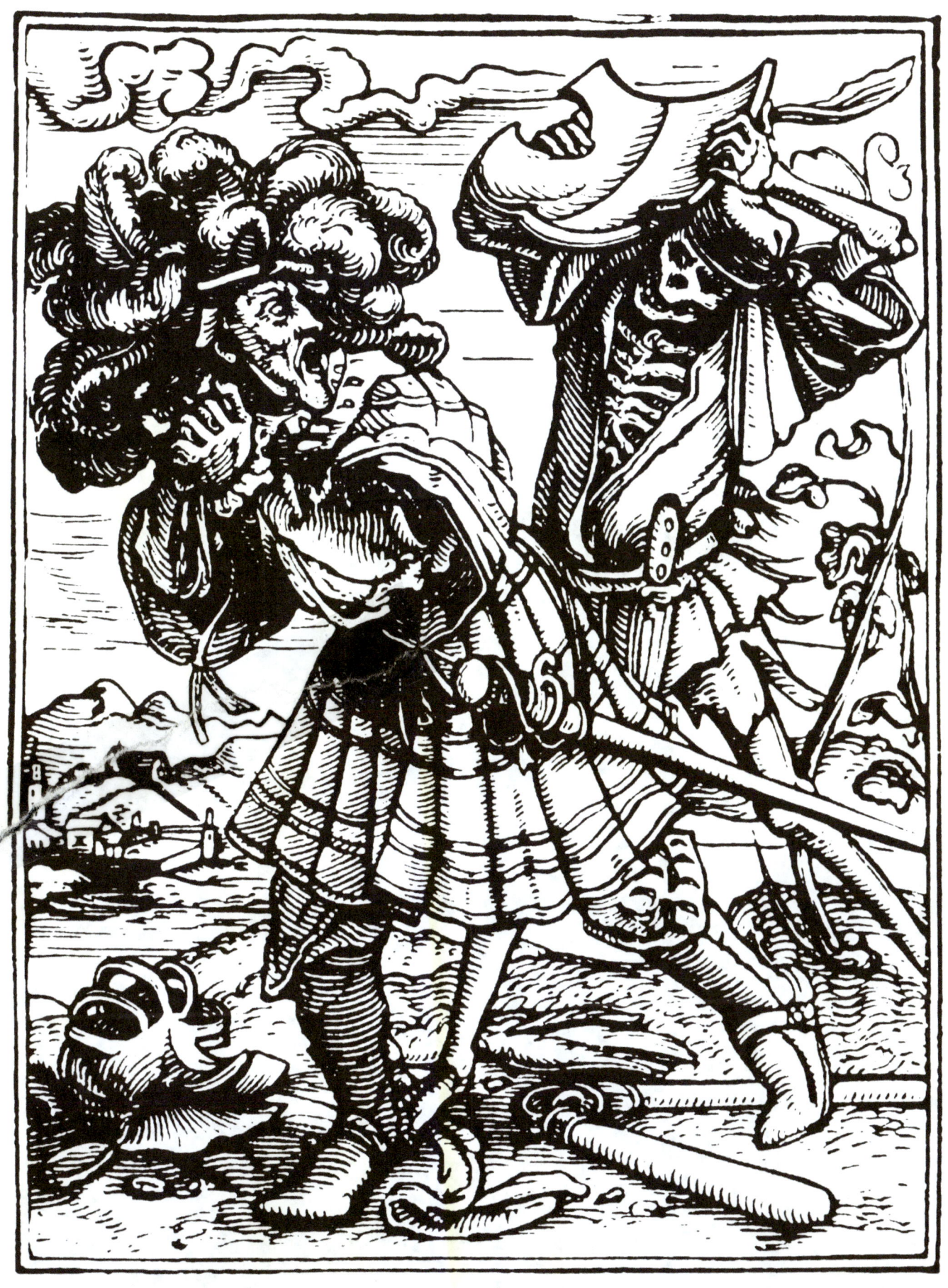

20 The Count

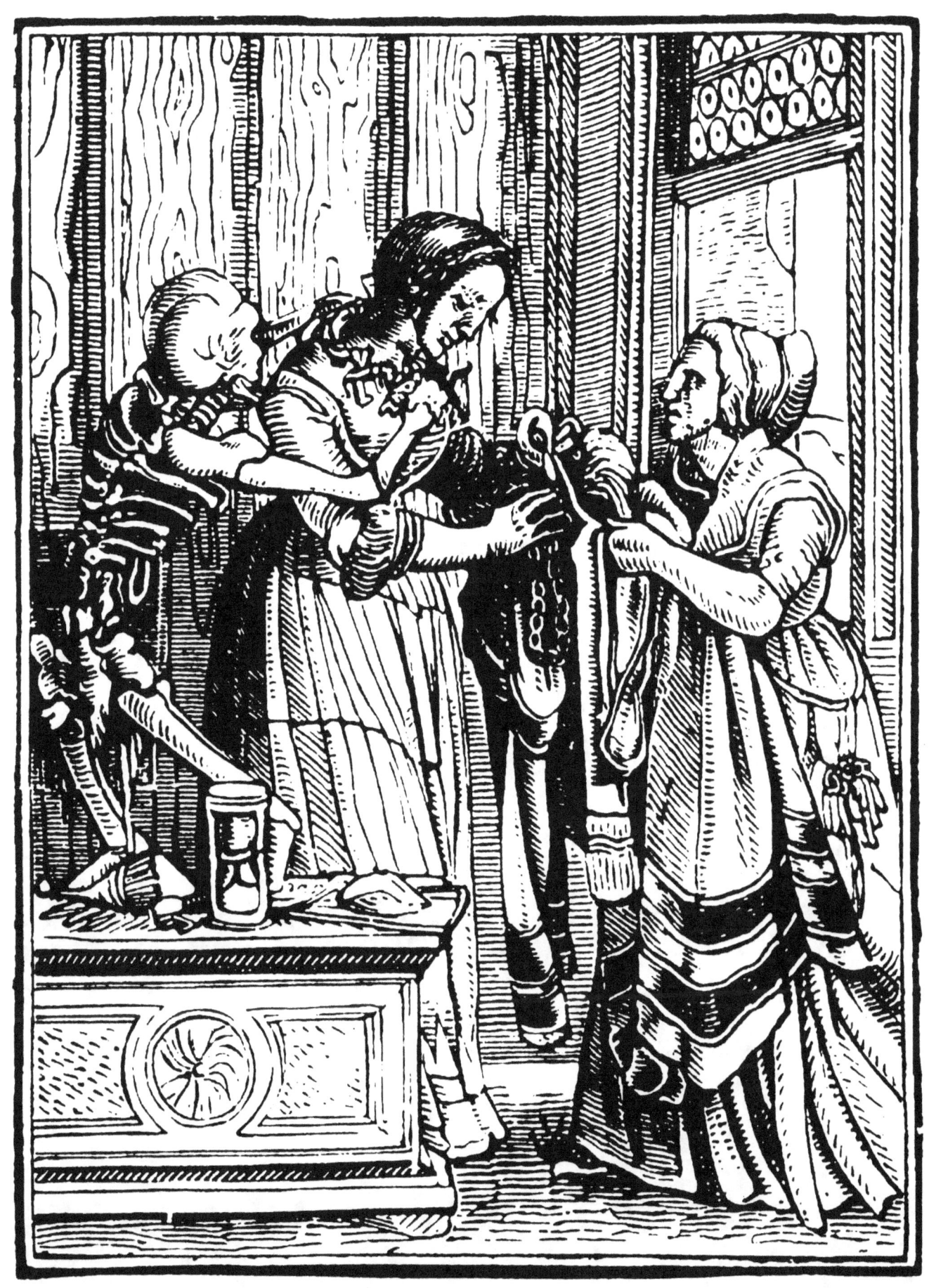

21 The Countess

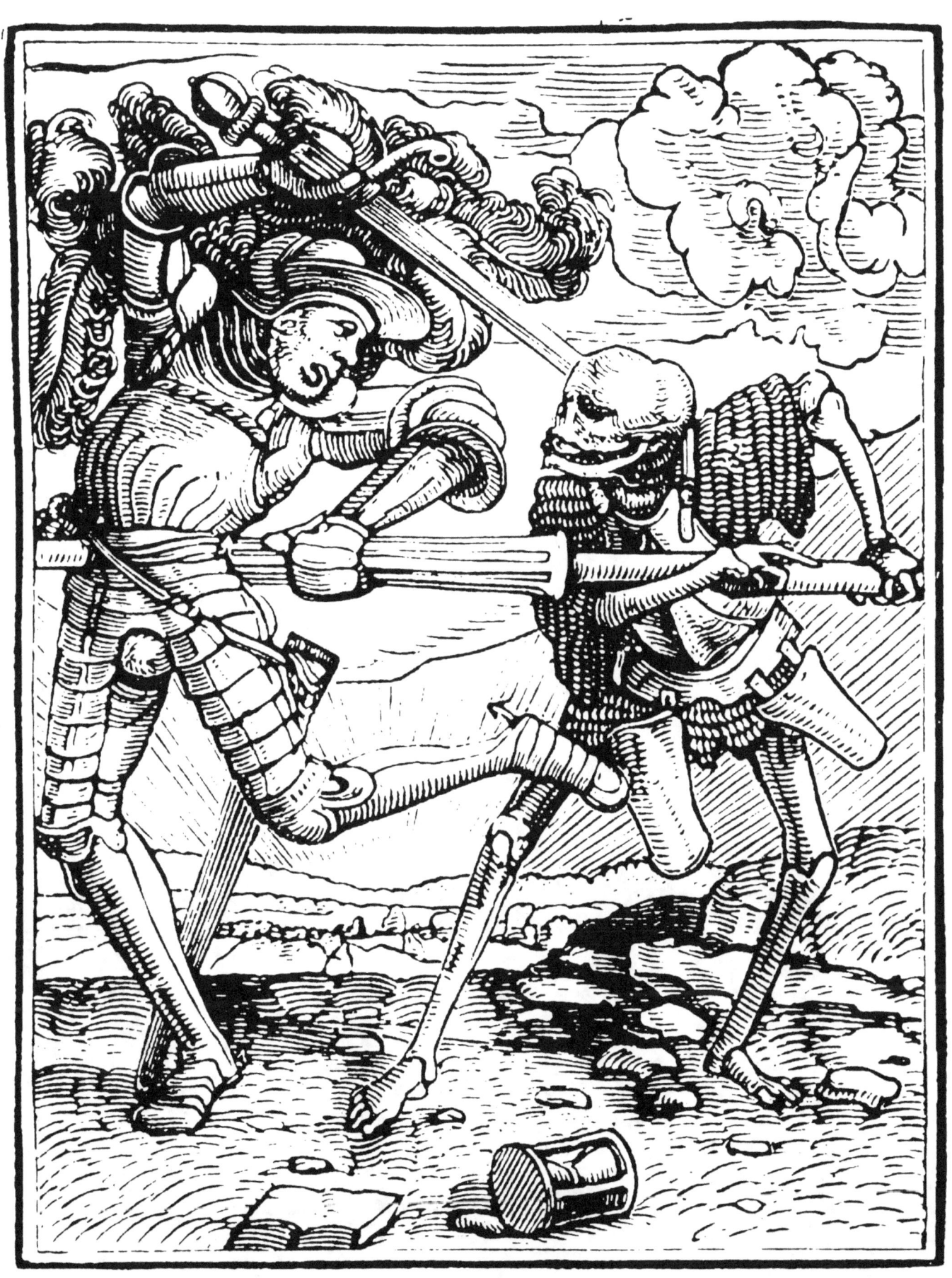

22 The Knight

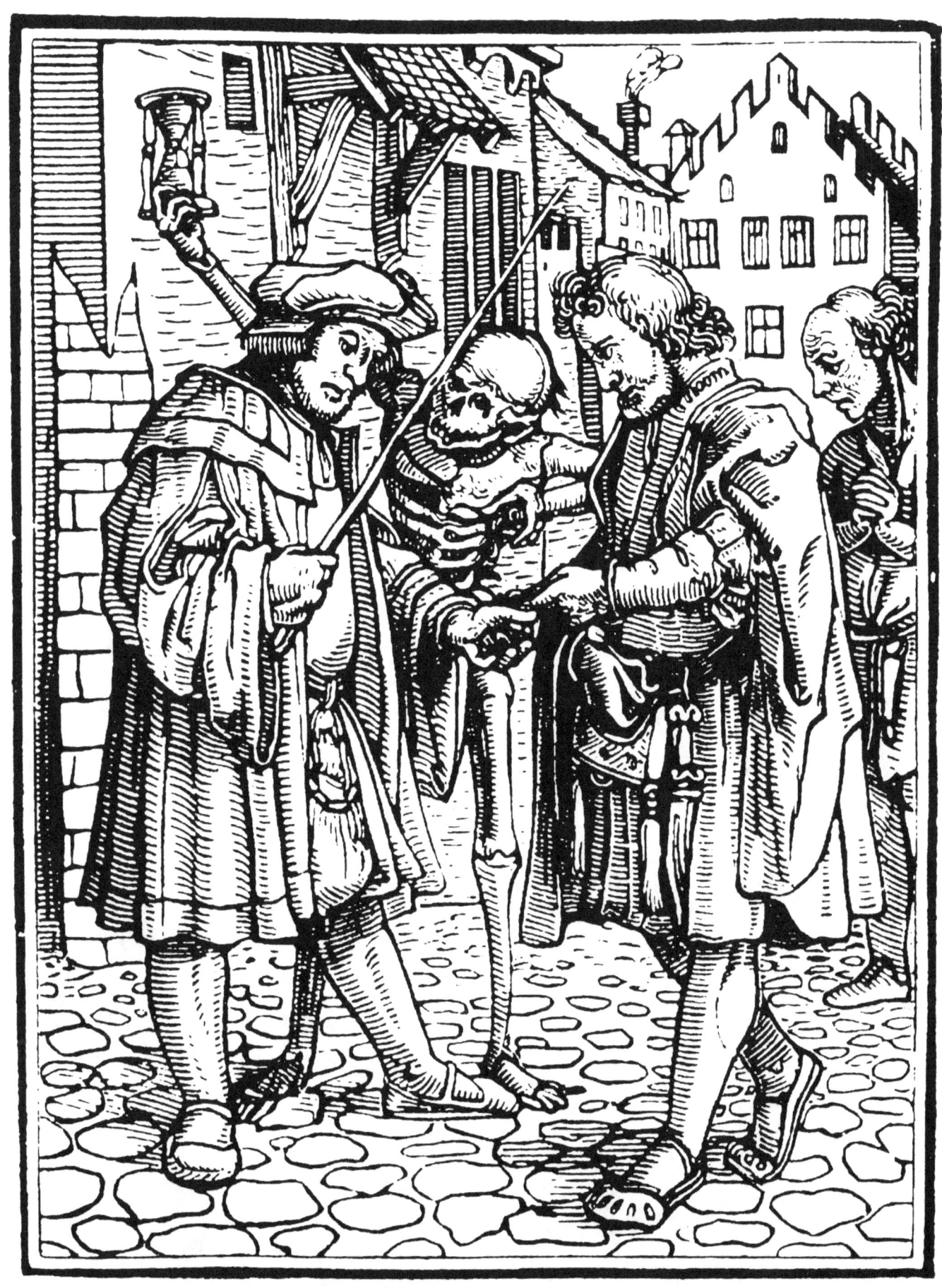

23 The Advocate

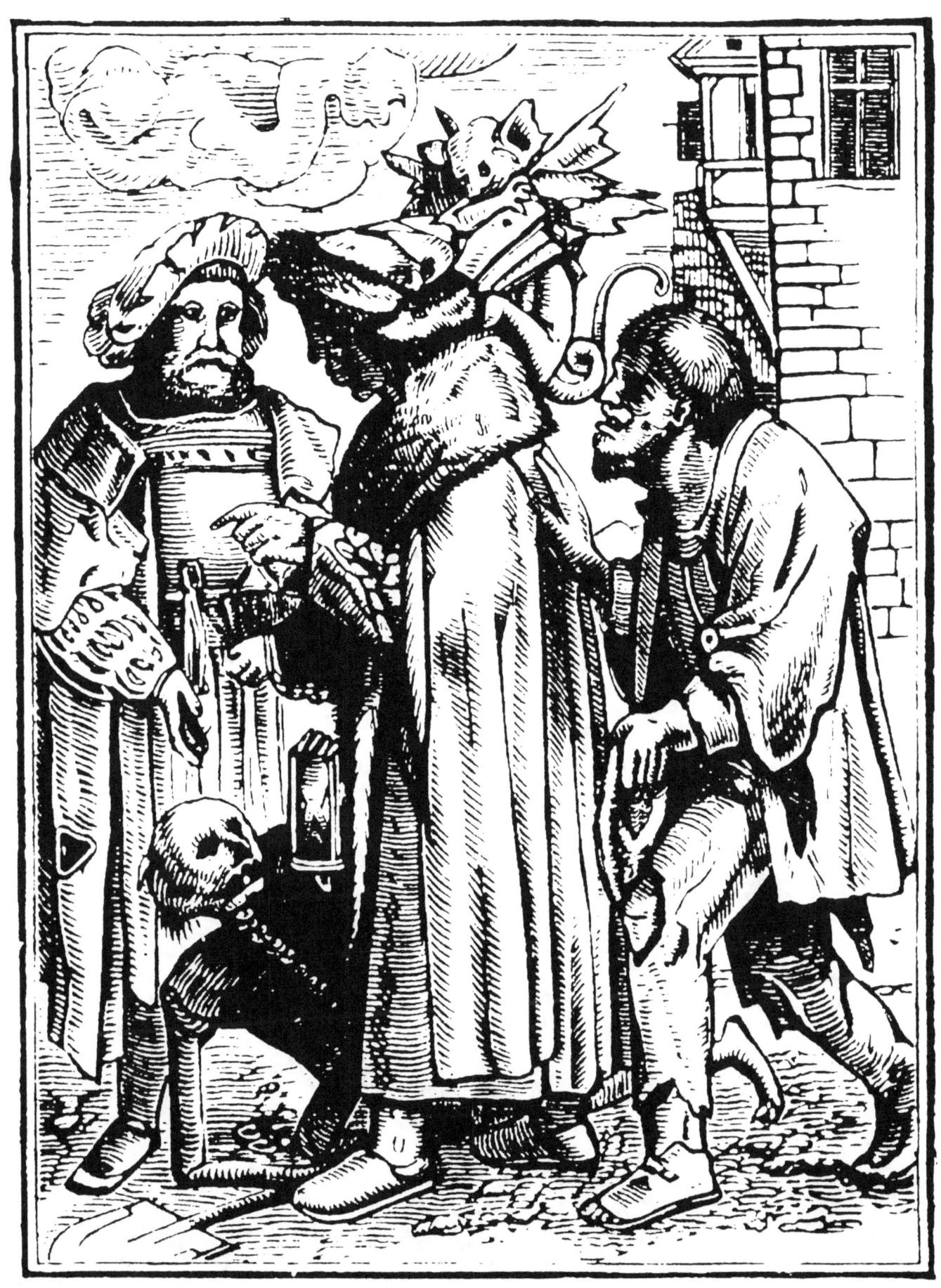

24 The Magistrate

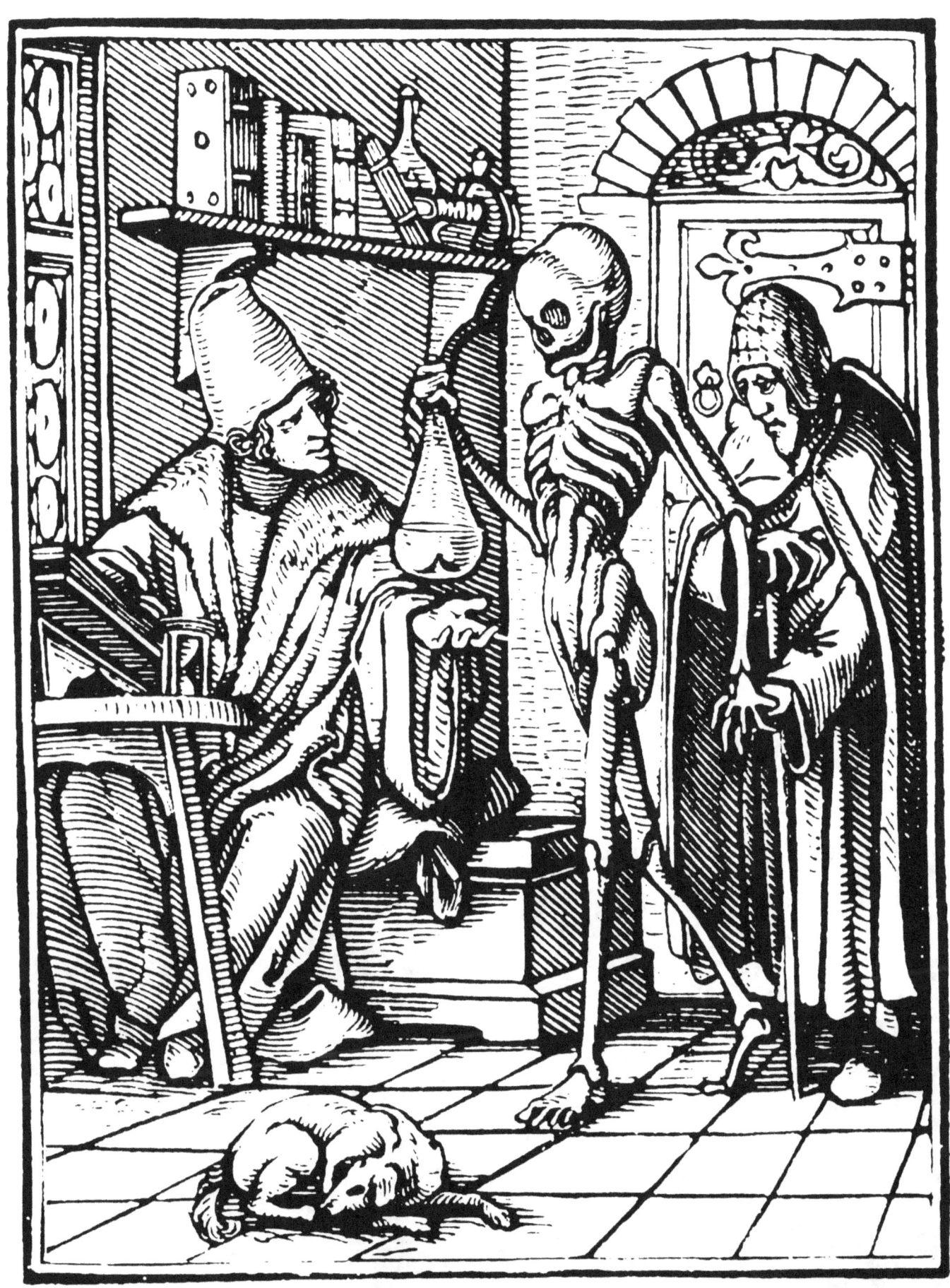

25 The Physician

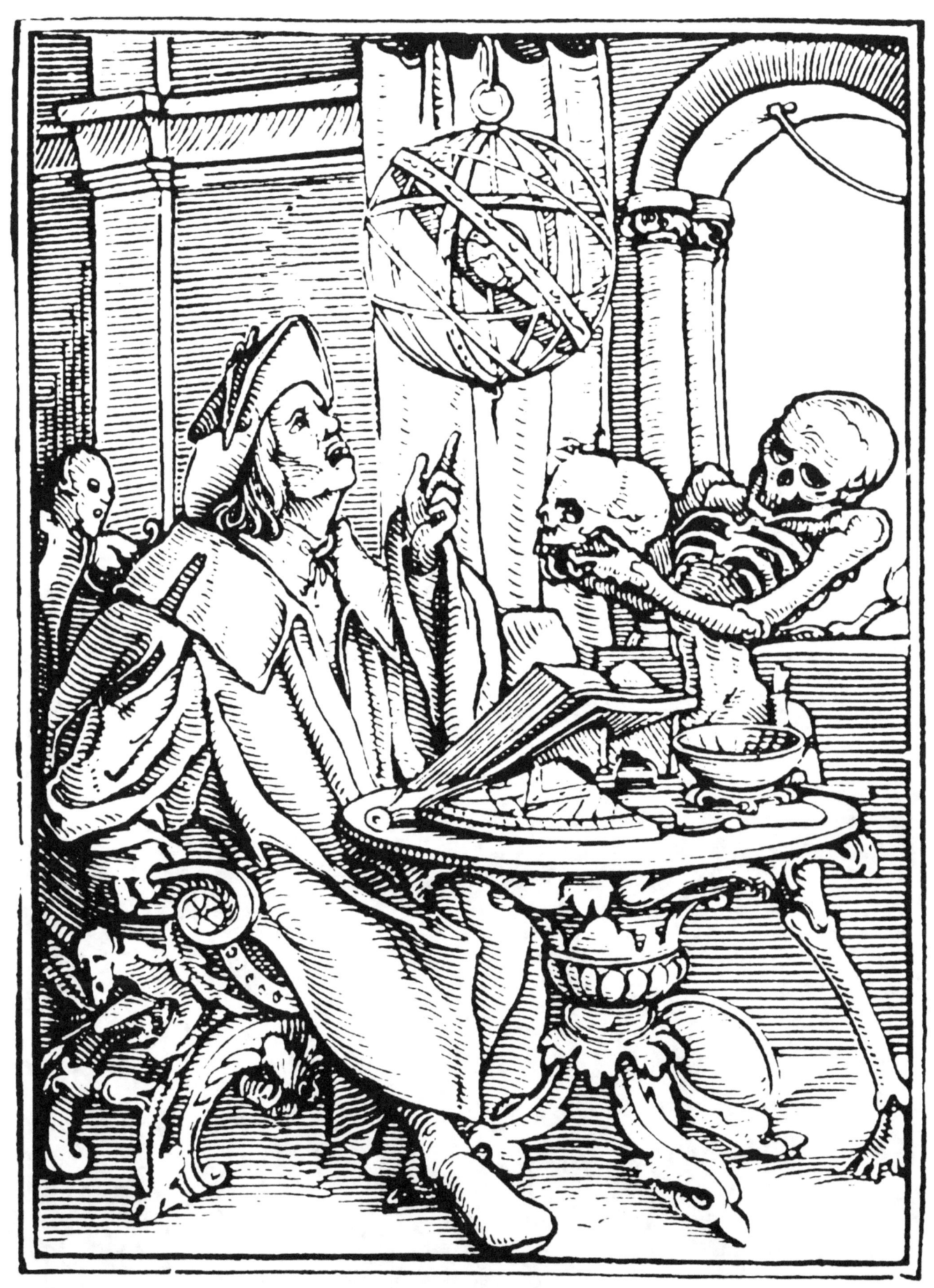
26 The Astrologer

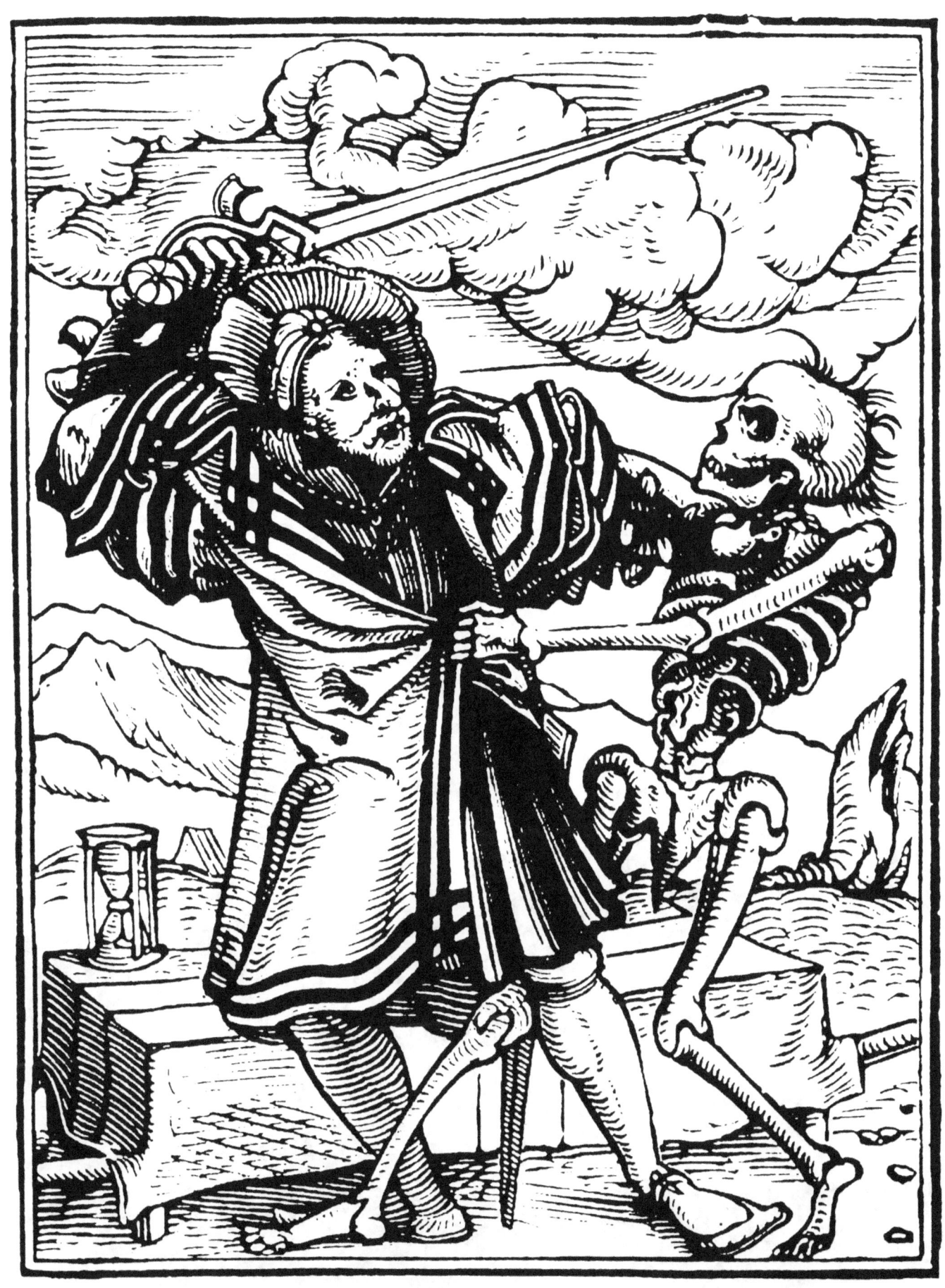

27 The Gentleman

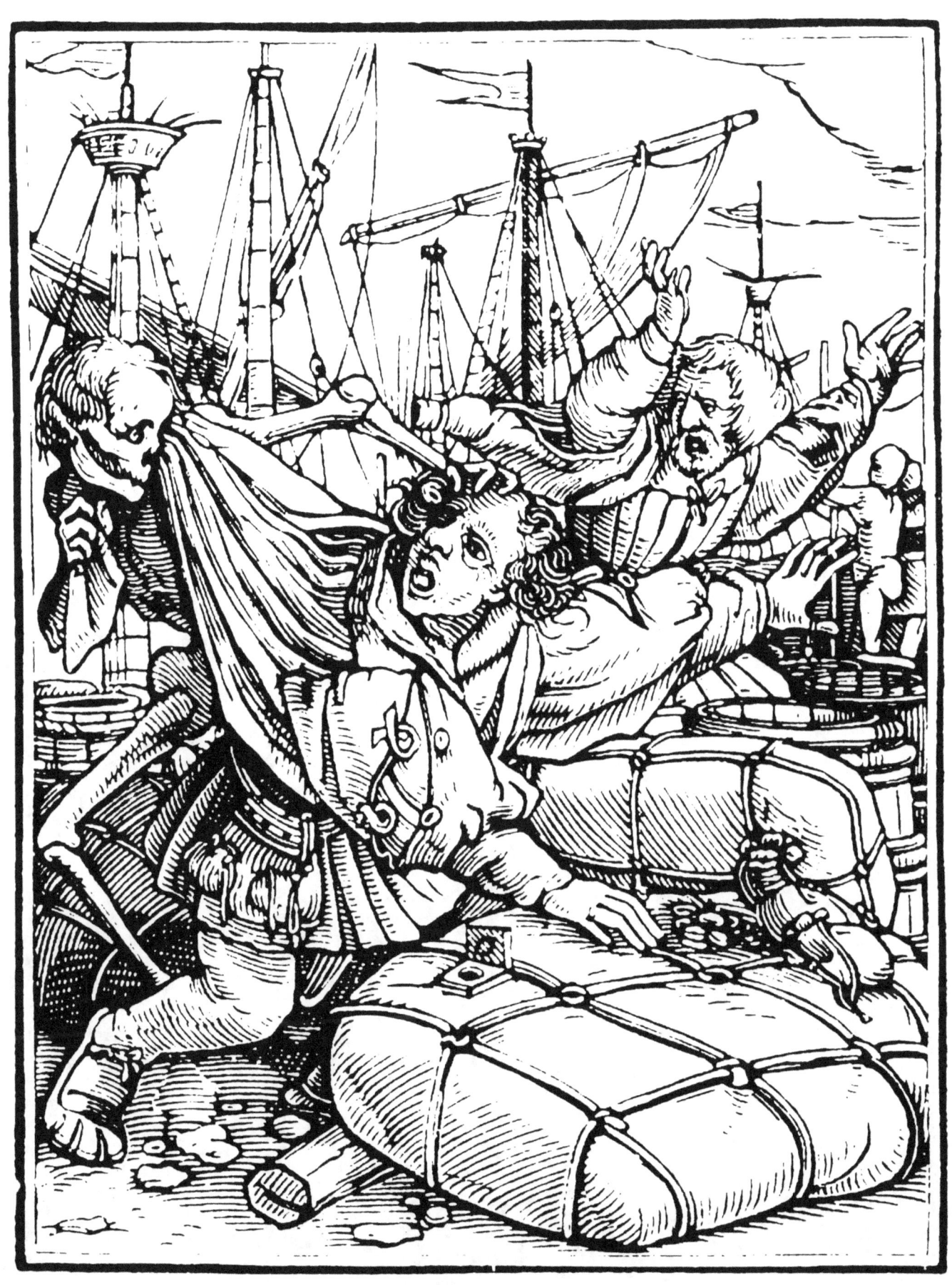

28 The Merchant

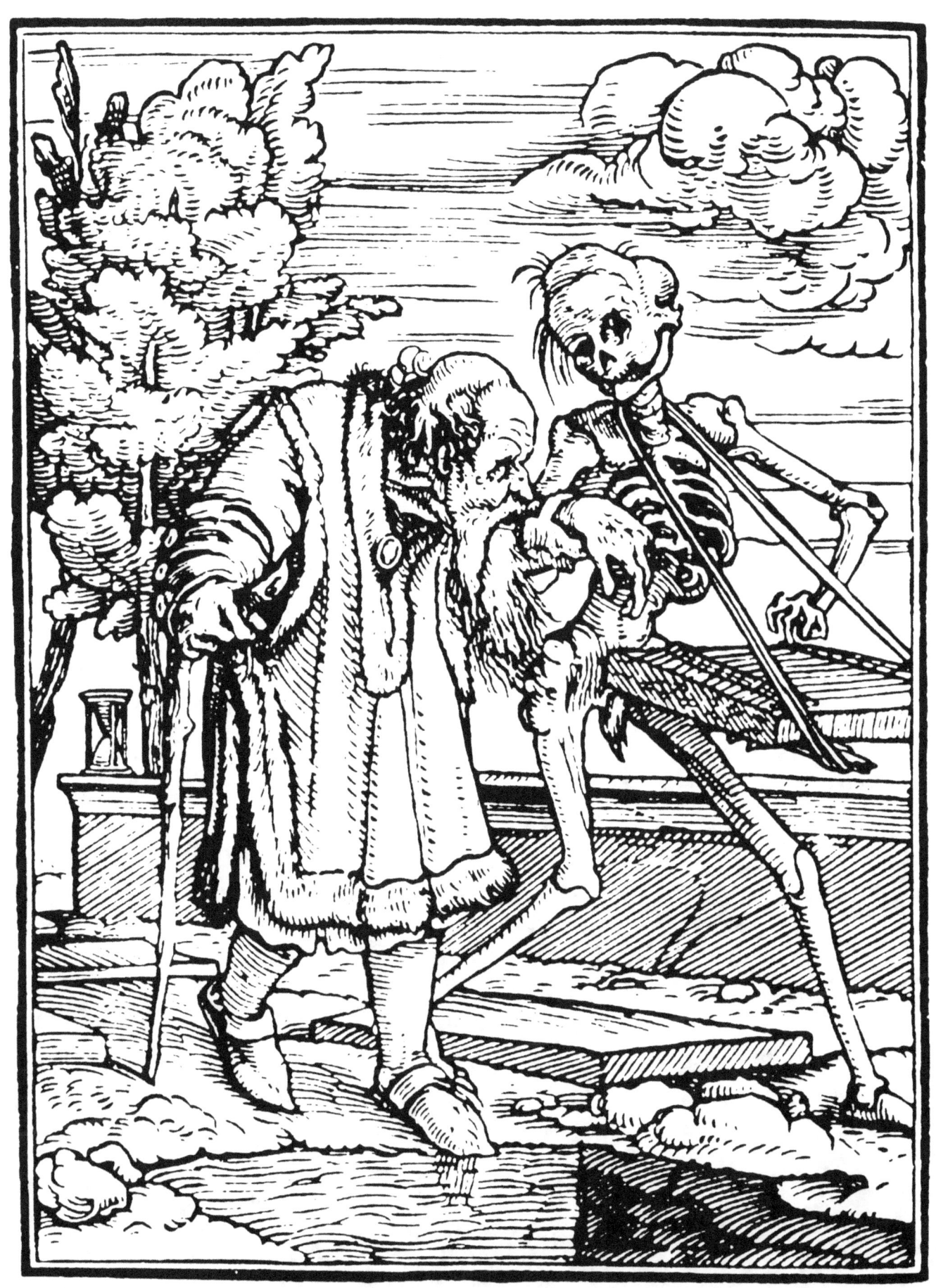

29 The Old Man

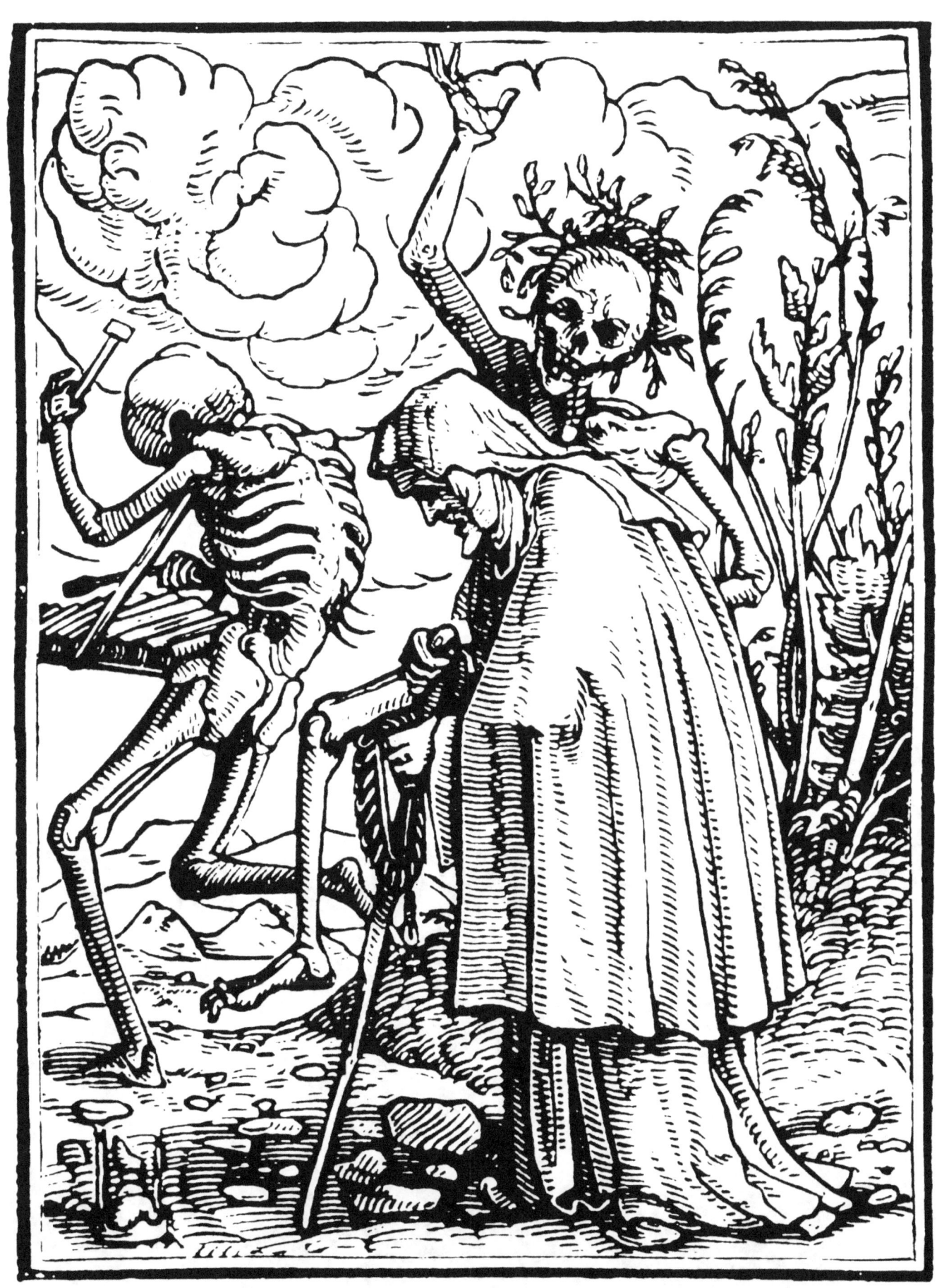

30 The Old Woman

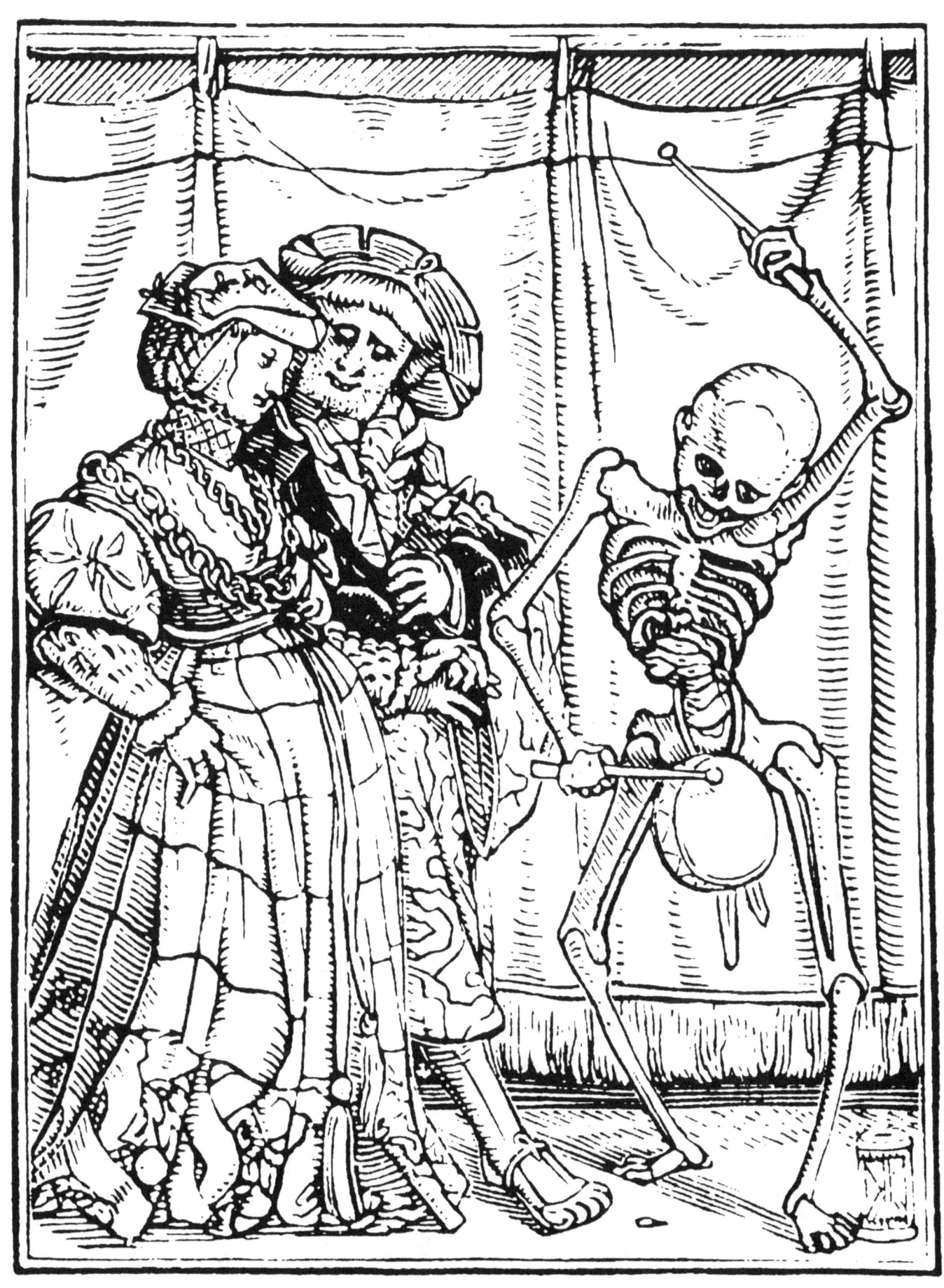
31 The Bride and Groom

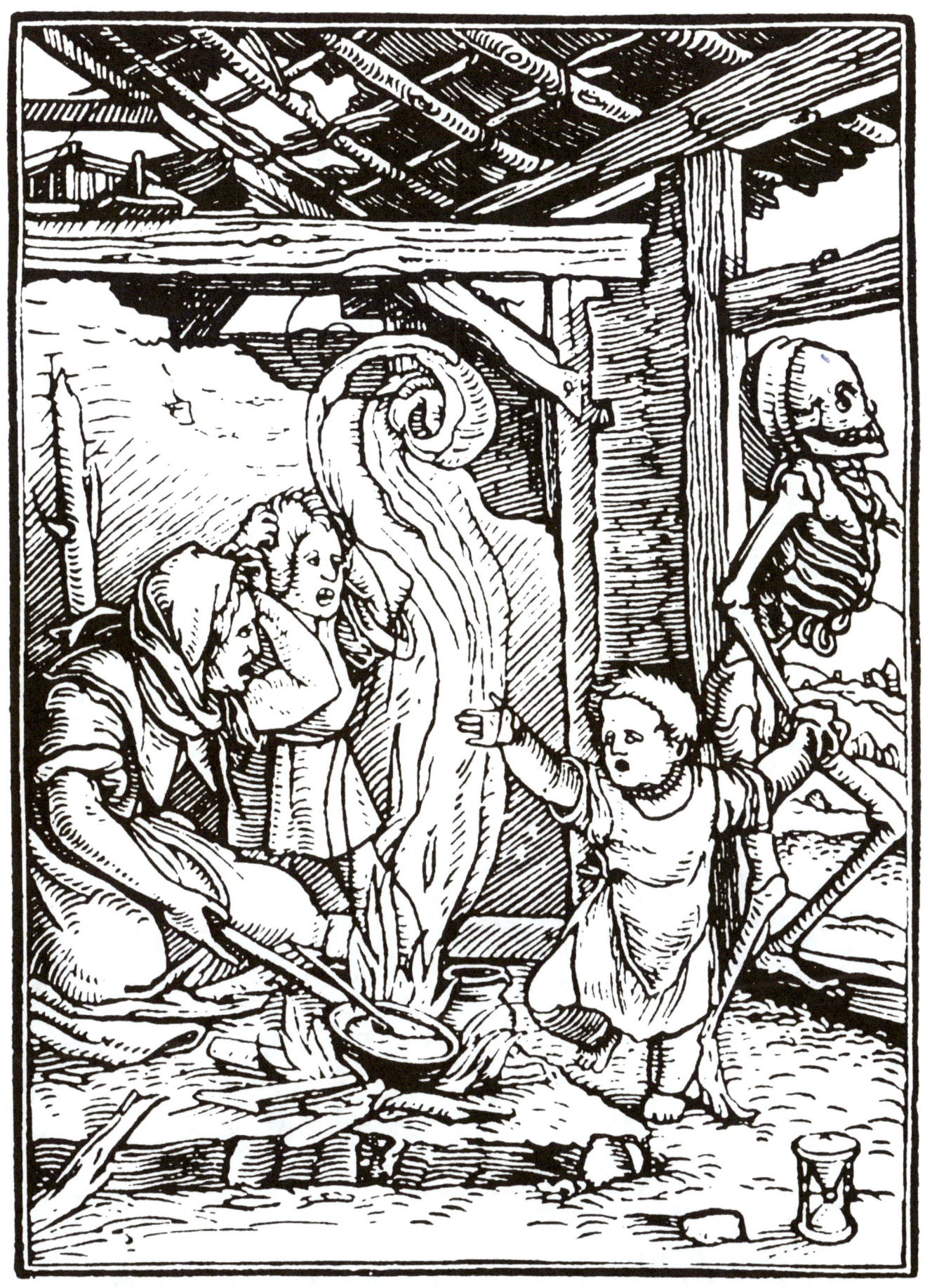

32 The Child

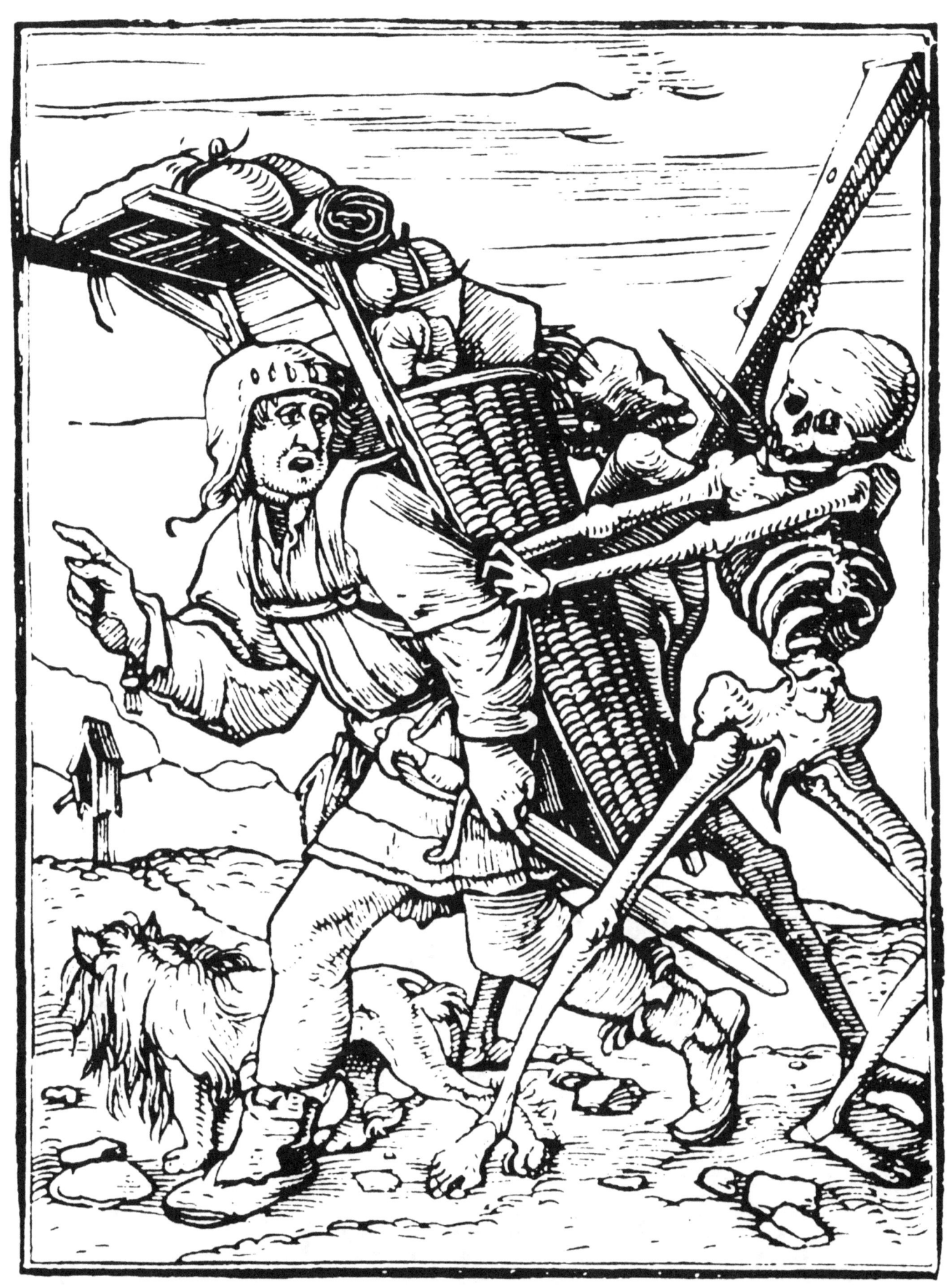

33 The Peddler

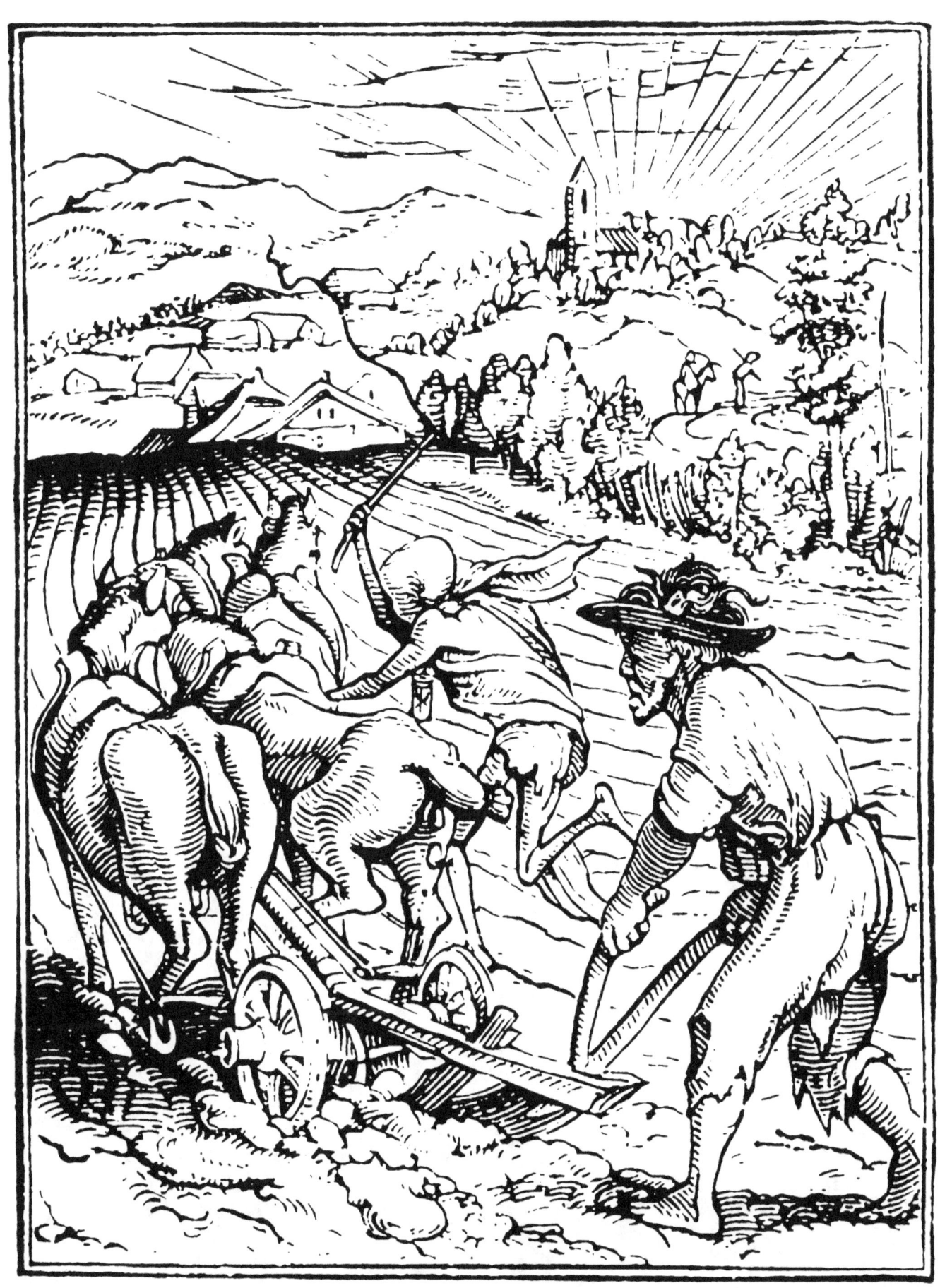

34 The Husbandman

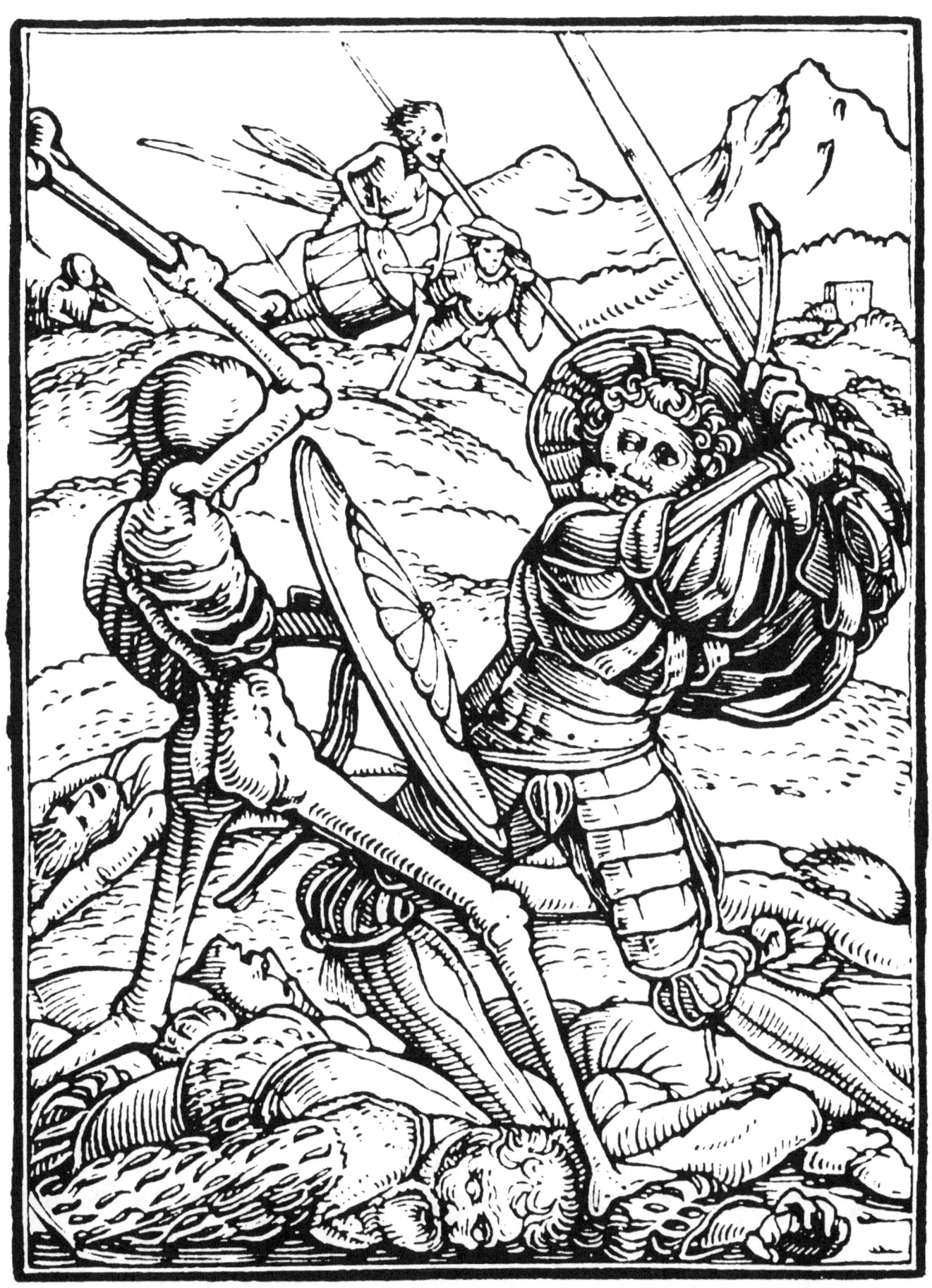
35 The Soldier

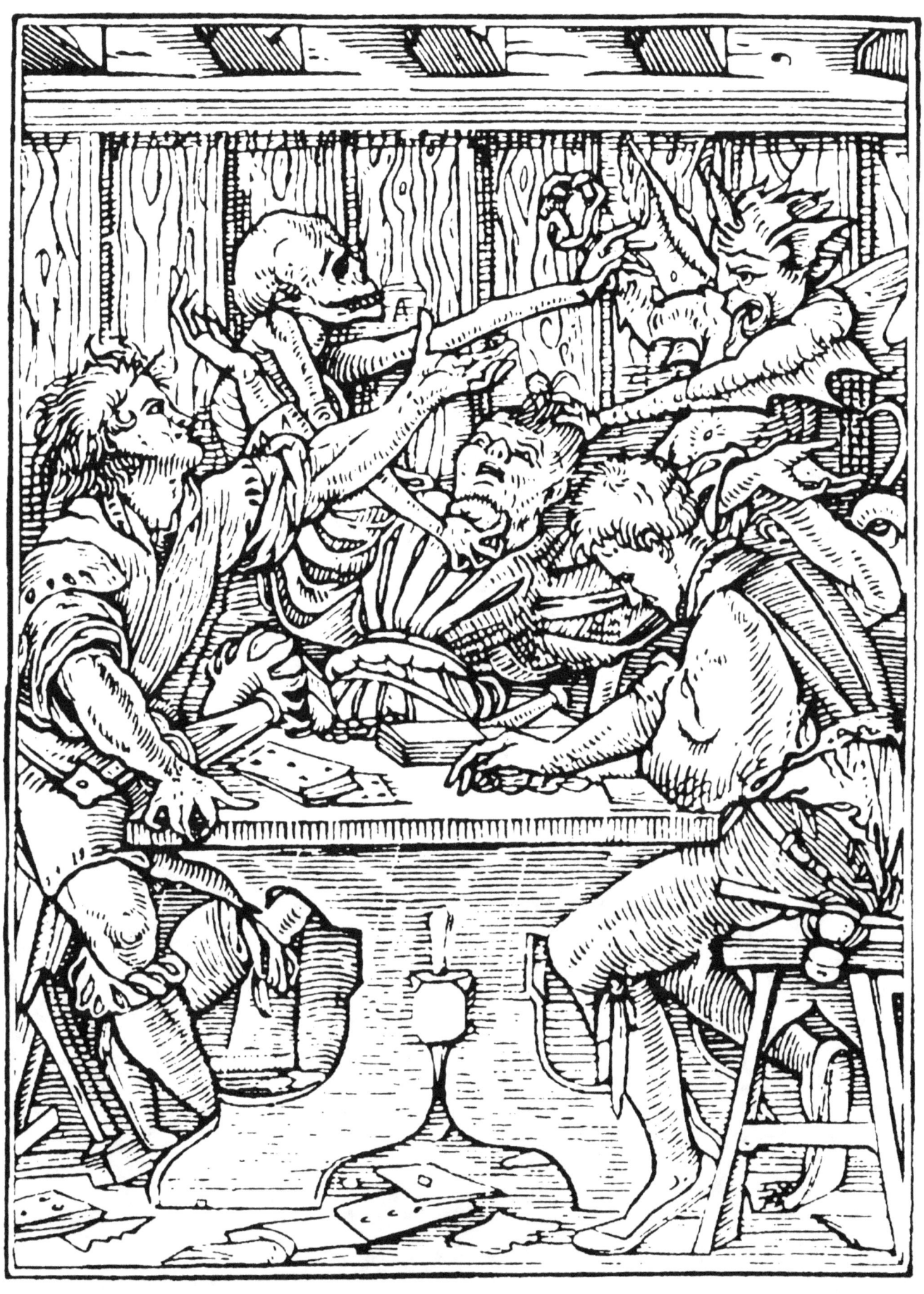

36 The Gamblers

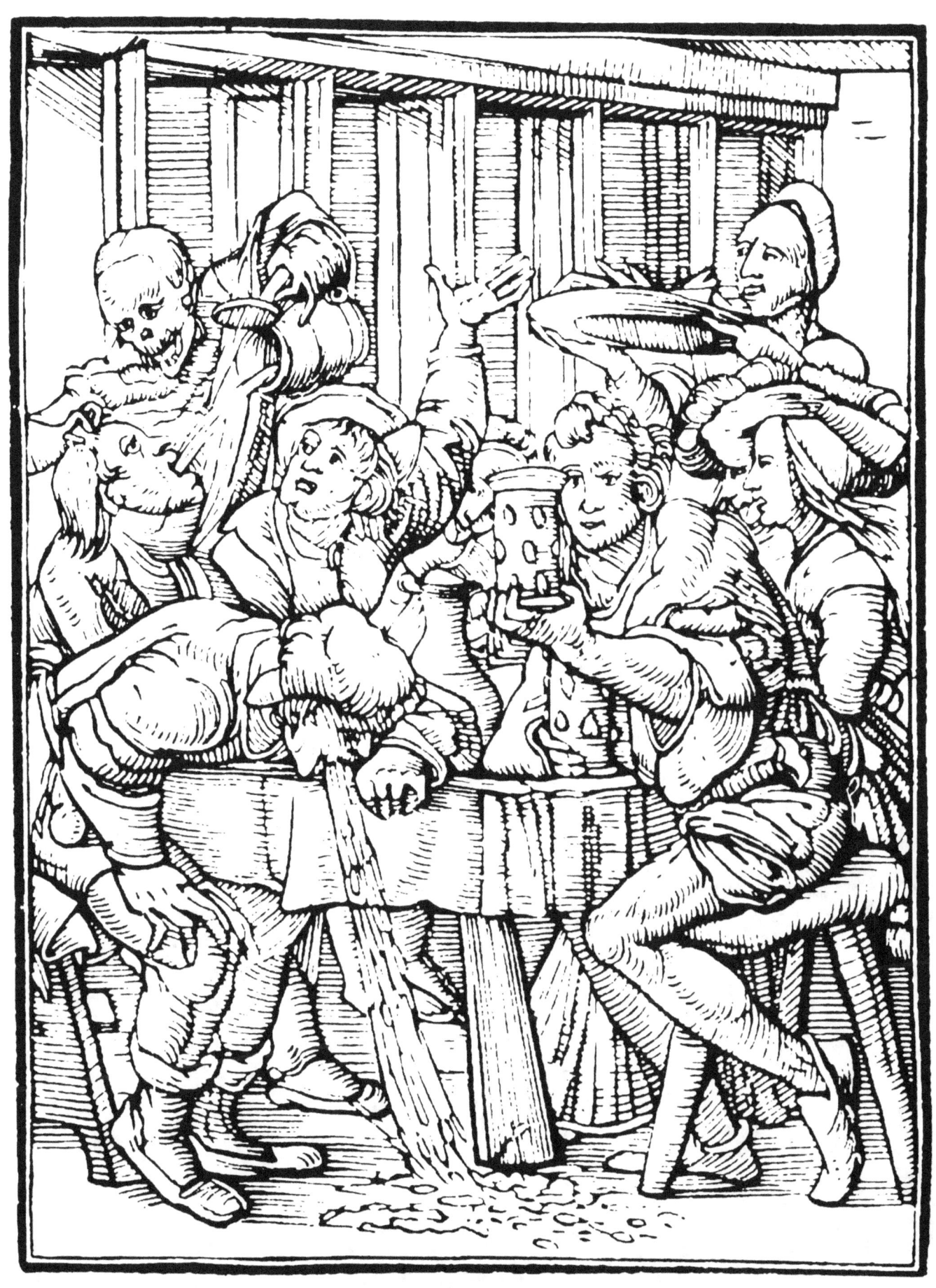

37 The Drunkards

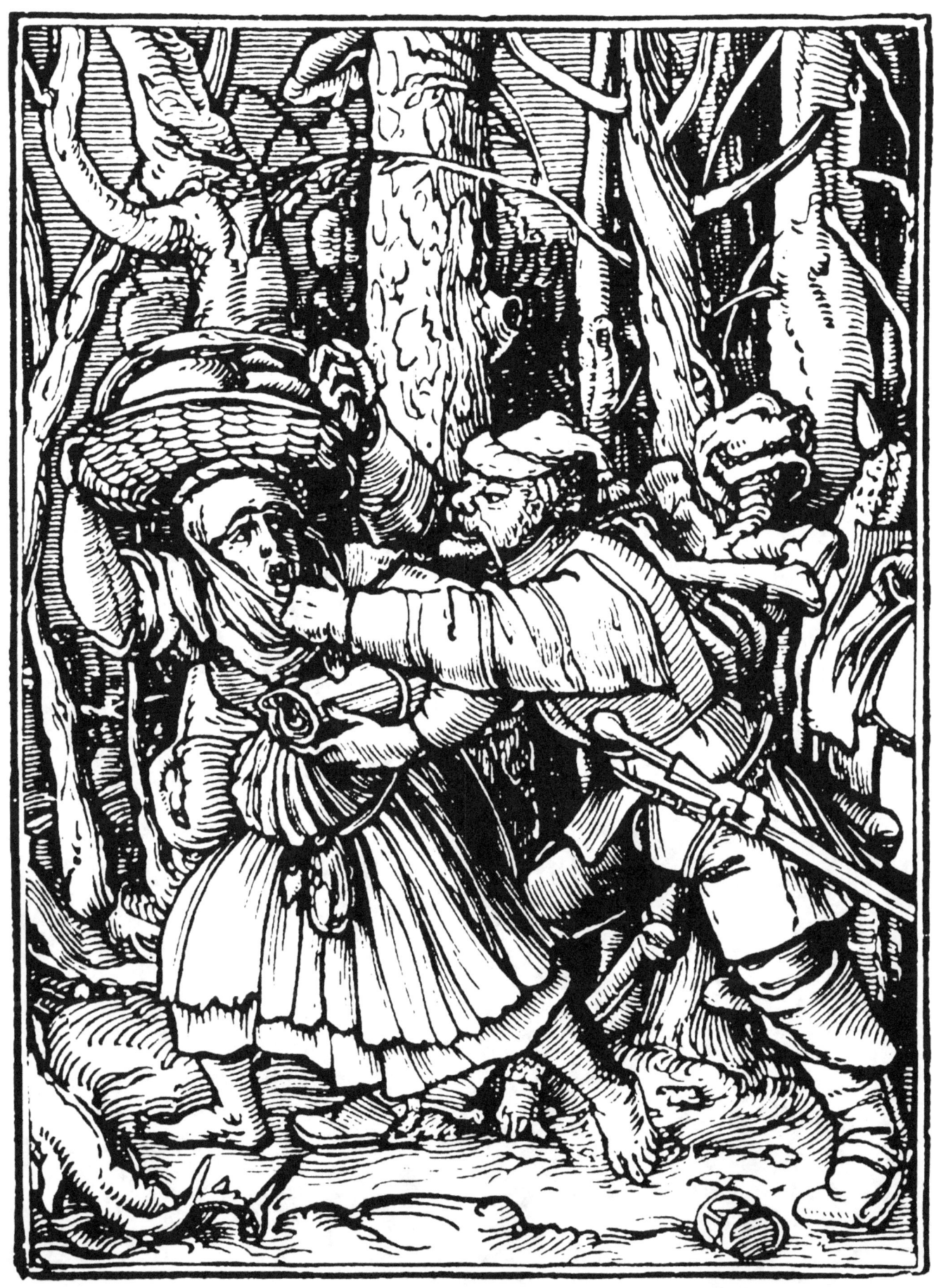

38 The Robber

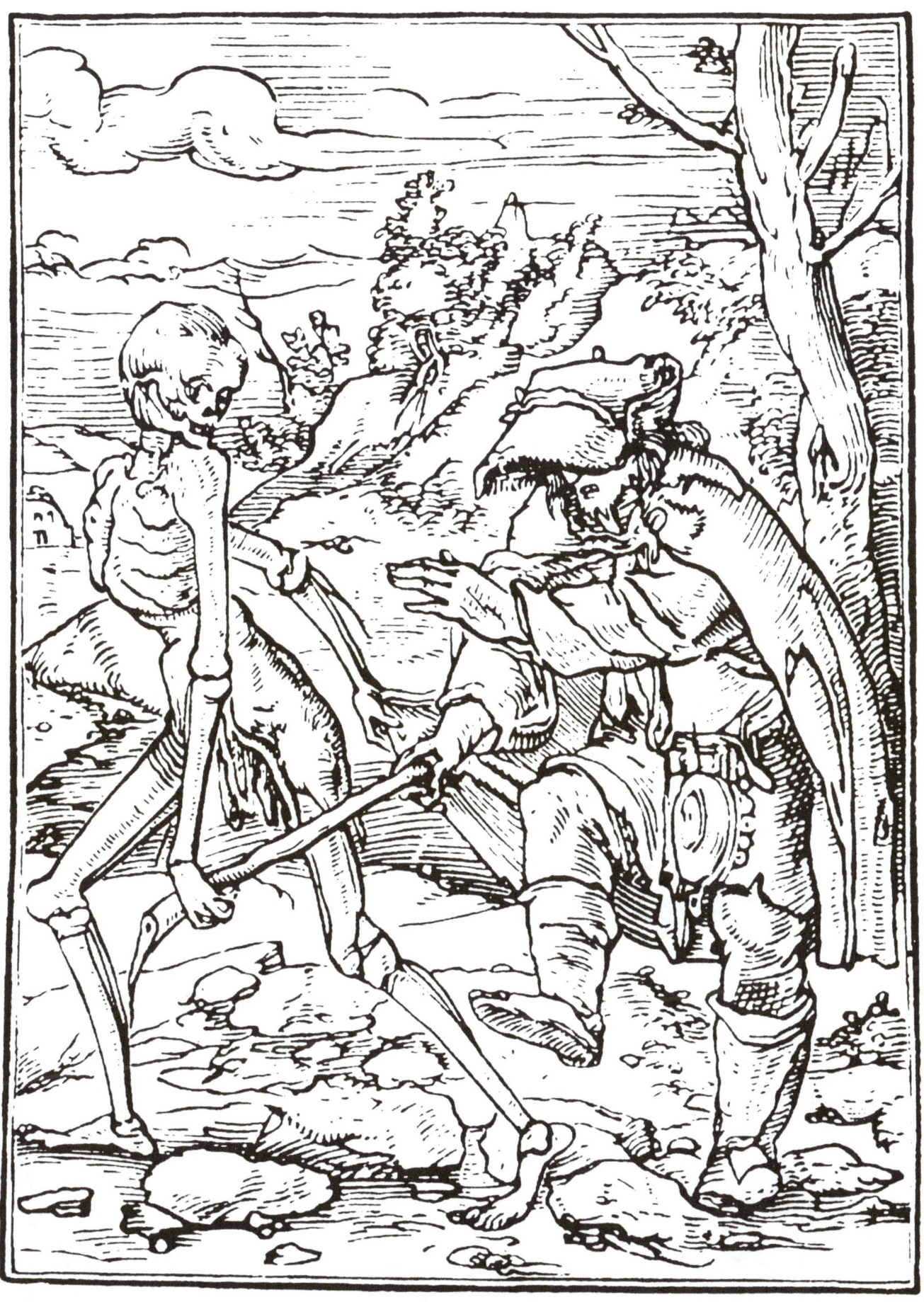

39 The Blind Man

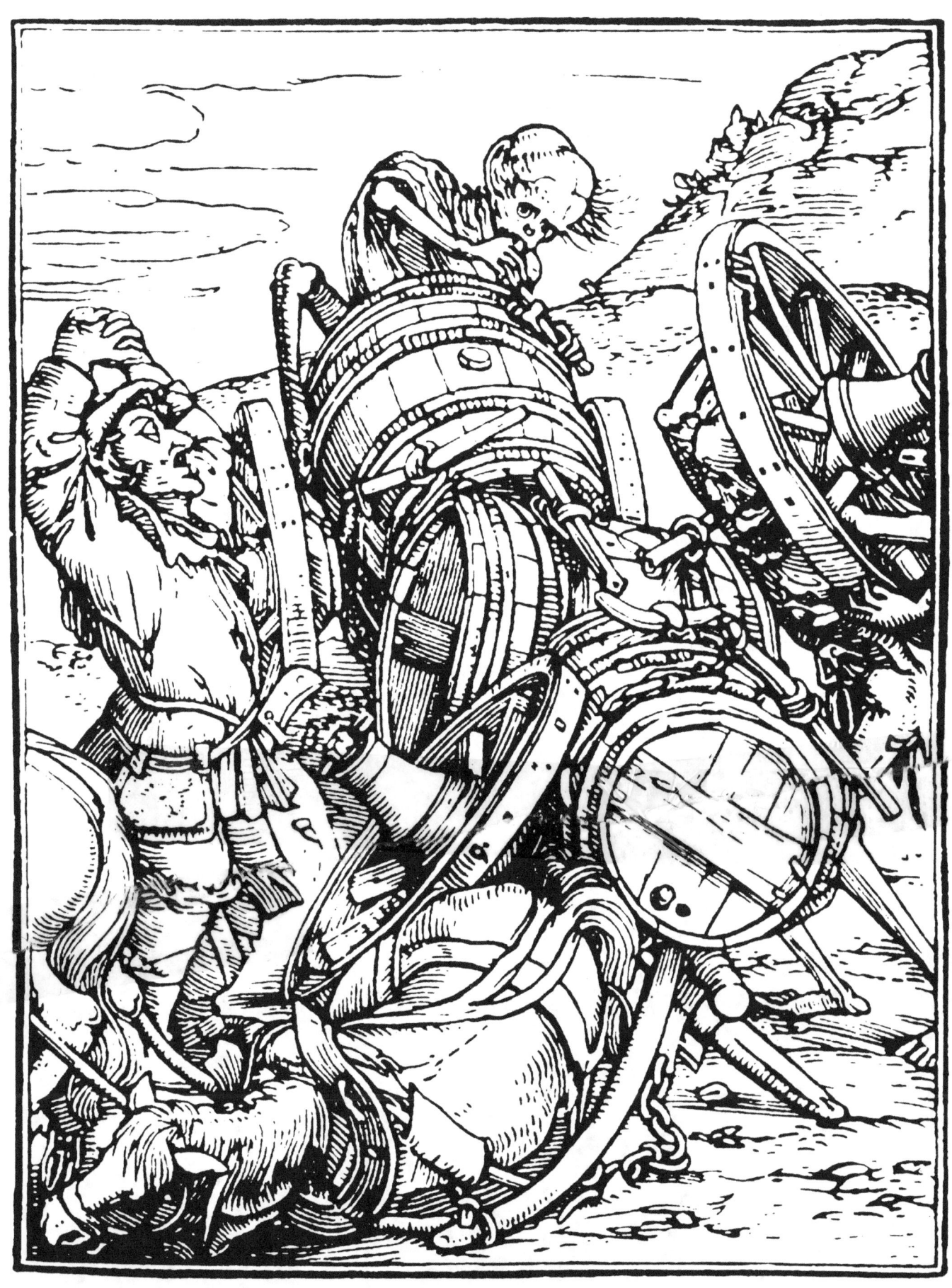

40 The Wagoner

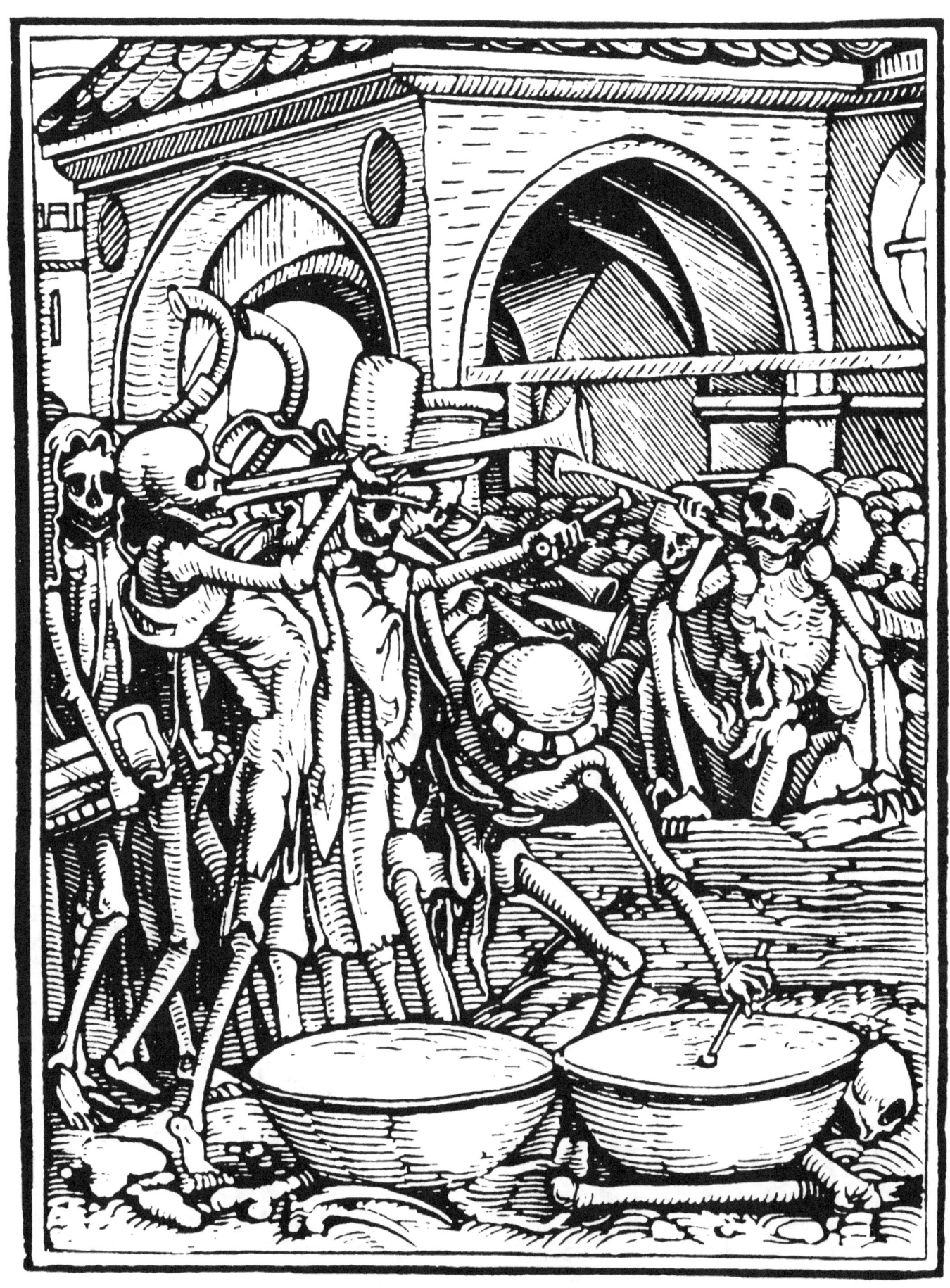

41 The Cemetery

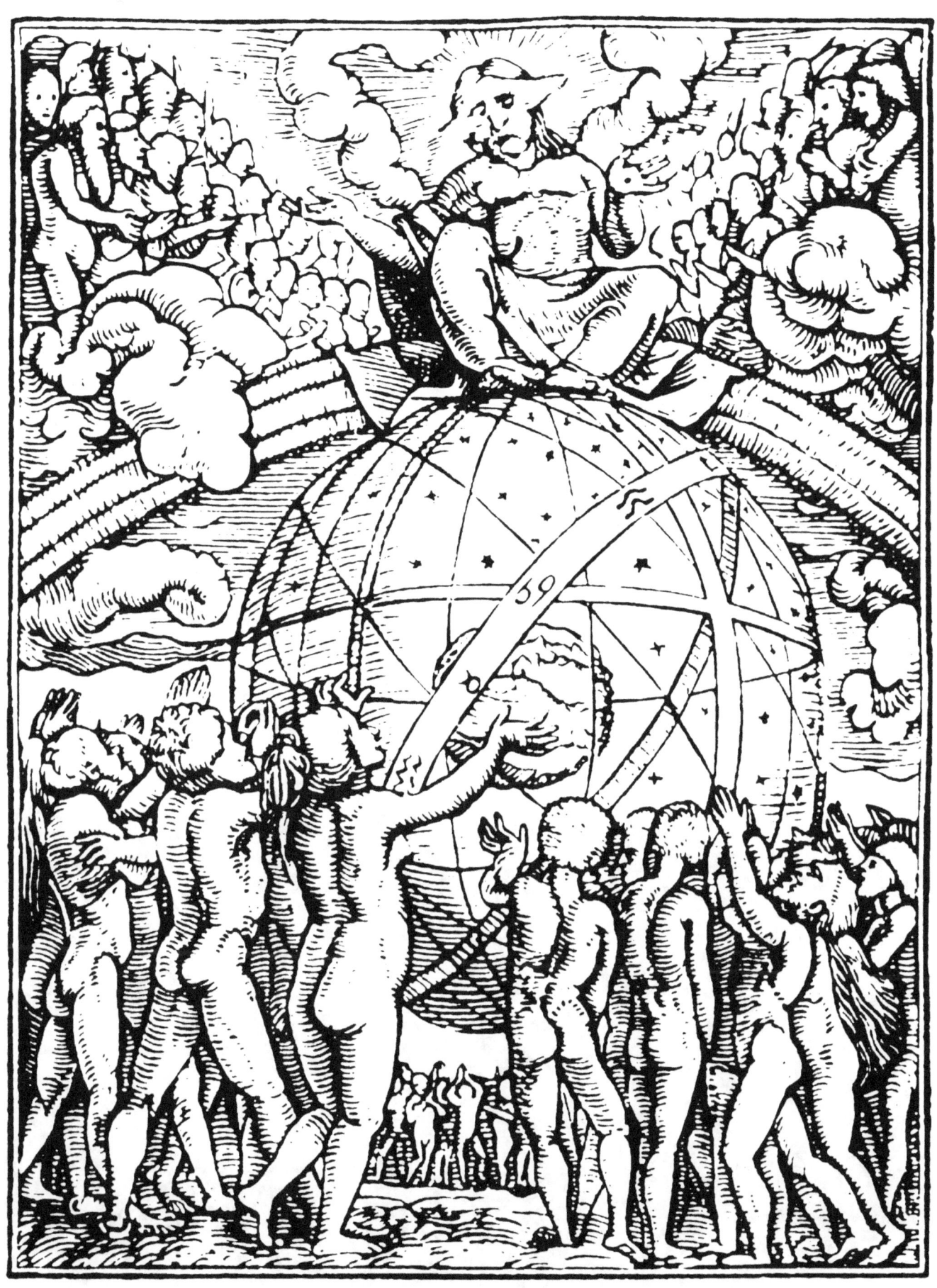

42 The Last Judgment